Dream of Colors

stress relieving adult coloring book with

flowers, trees, plants and so much more

Parnaz Azizi & Golenaz Azizi

Copyright © 2019 Parnaz & Golenaz Azizi

All rights reserved.

ISBN: 978-1-09-315189-3

Coloring is meditative & great for relaxation. It helps focus the mind & allows the imagination to play Playing with colors is so great, try them on the color palette pages at the back of this book to mix them and make new colors and check if they bleed, Slip a sheet behind the page you are coloring to prevent transfer of ink and also you can slip a sheet under your hand, Enjoy coloring, enjoy your time, Have fun and color outside the lines… it's totally ok! ☺

40 Unique Designs to Color

- Originating from hand drawings by

 Parnaz and Golenaz Azizi

- Garden Designs, flowers, Animals, Patterns…
- Perfect For Every Skill Level
- Perfect With Your Choice Of Coloring Tools (Crayon, Gel Pens, Markers, Colored Pencils)
- Each Coloring Page Is On One Sheet. Printed One Sided to Avoid Bleed Through

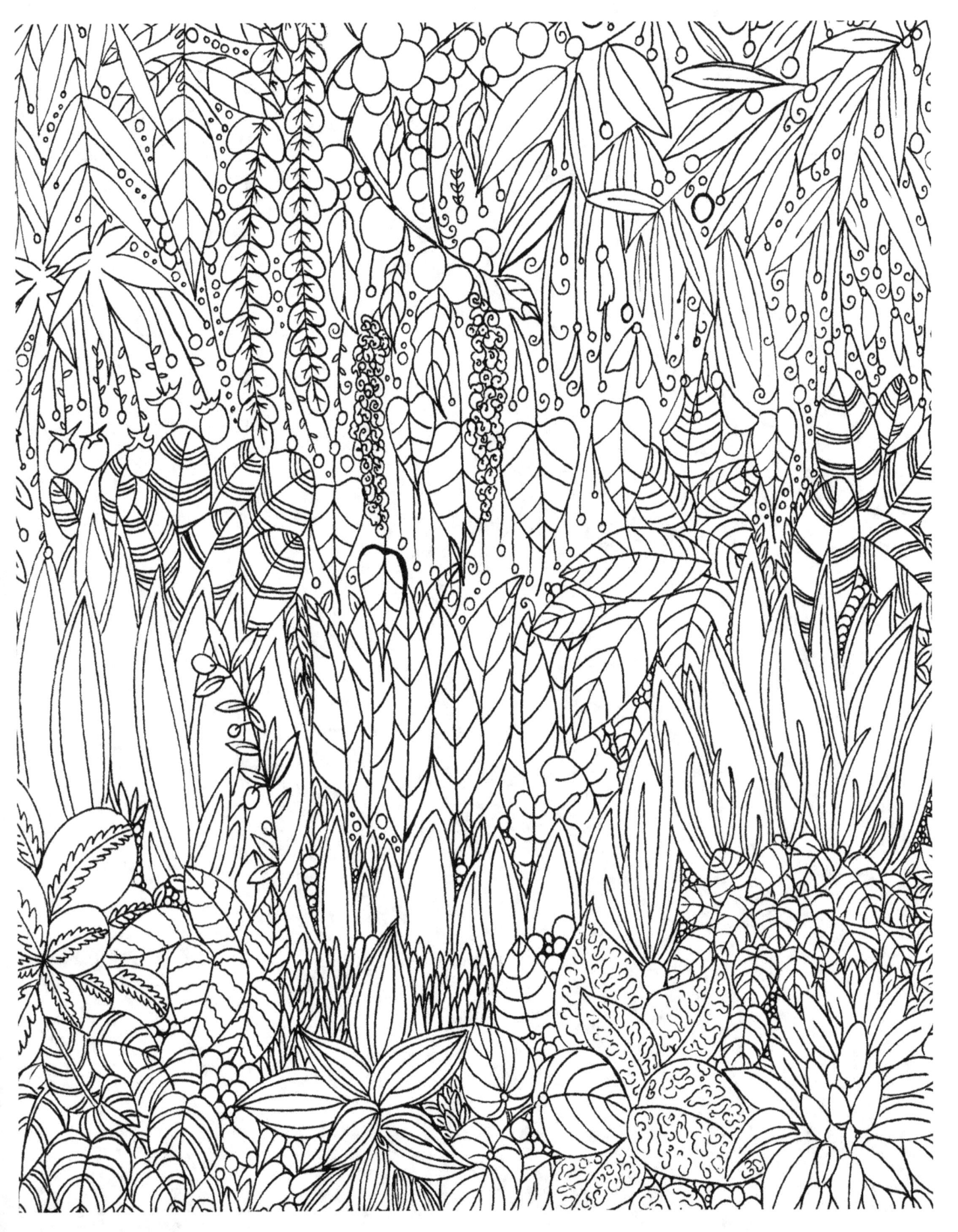

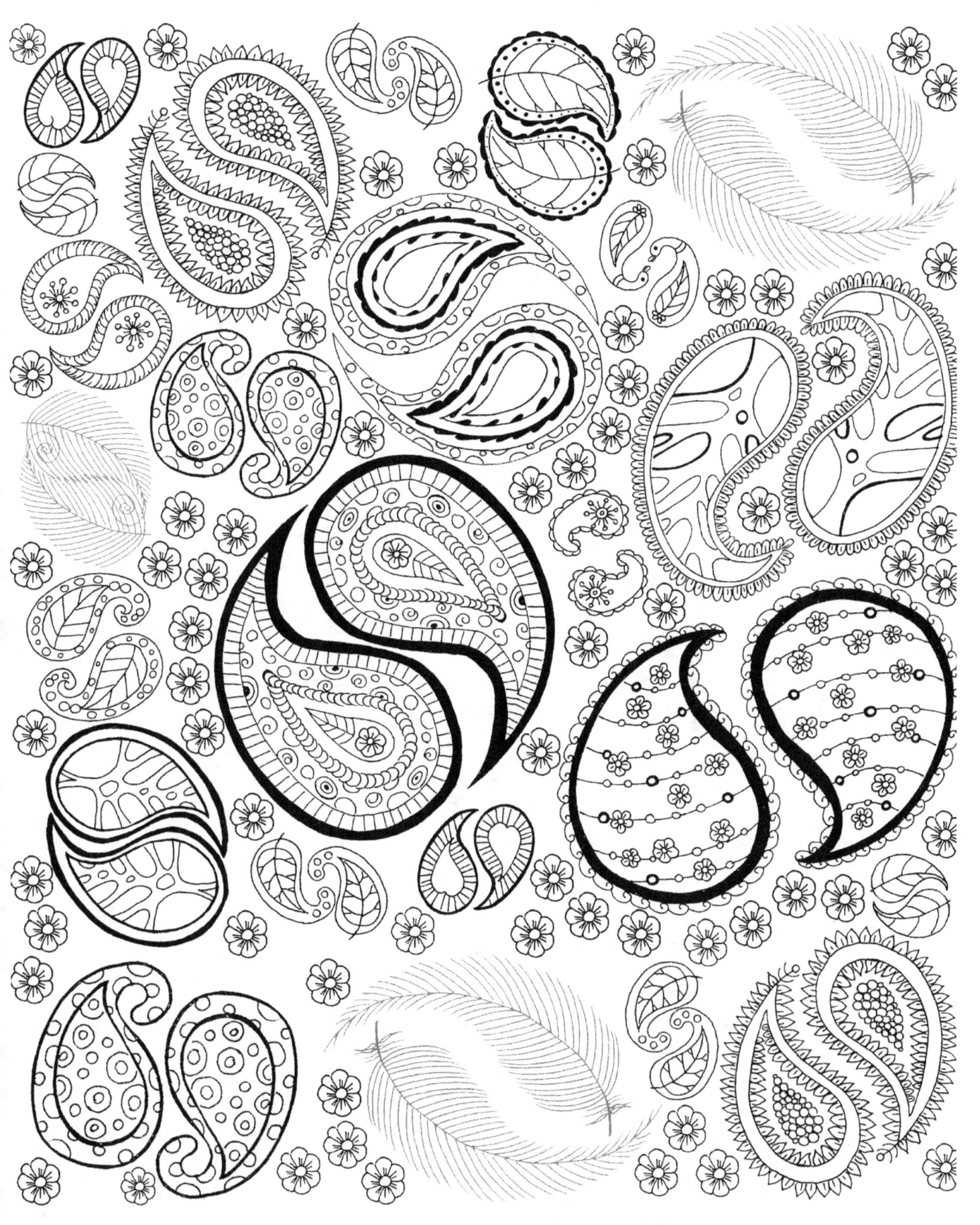

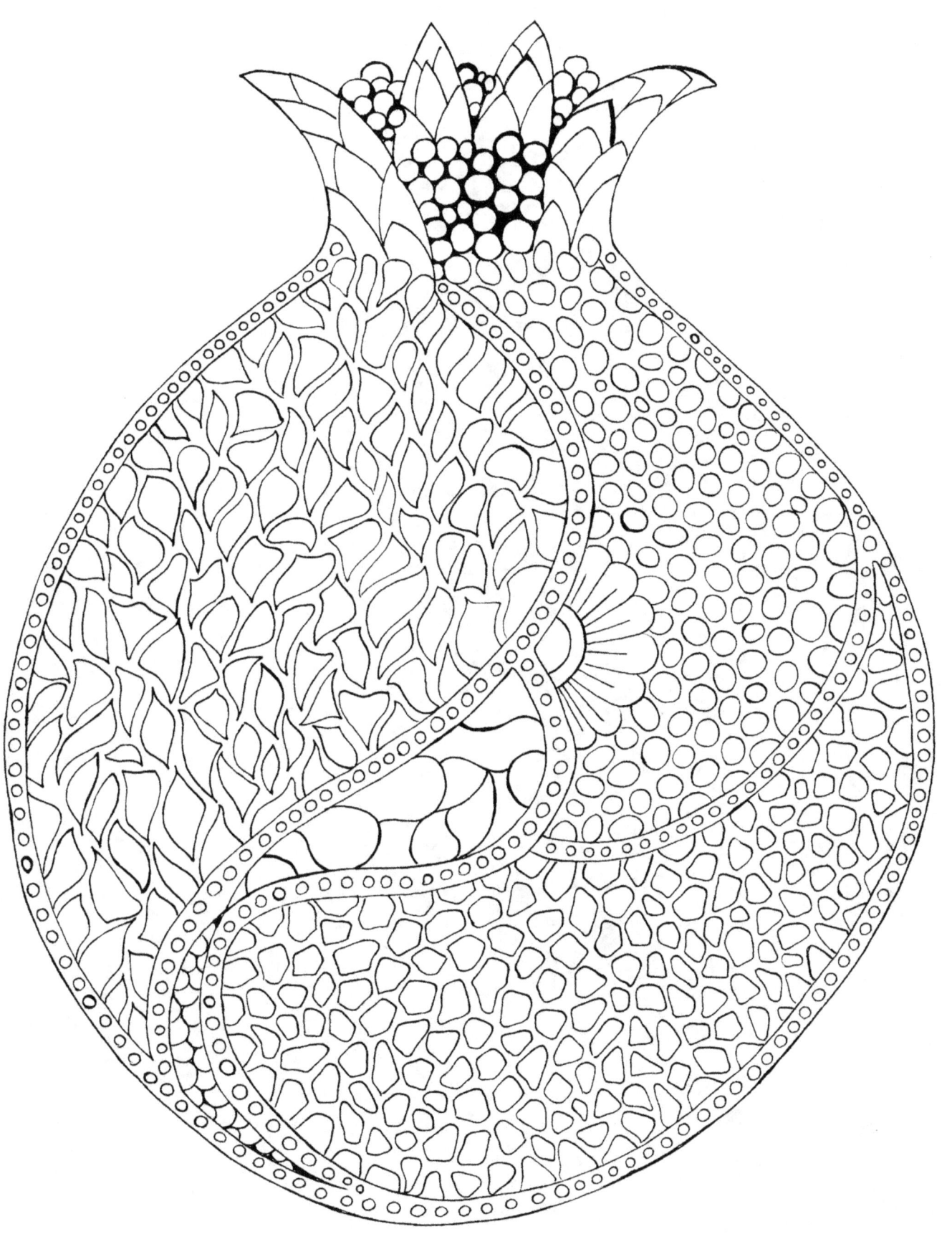

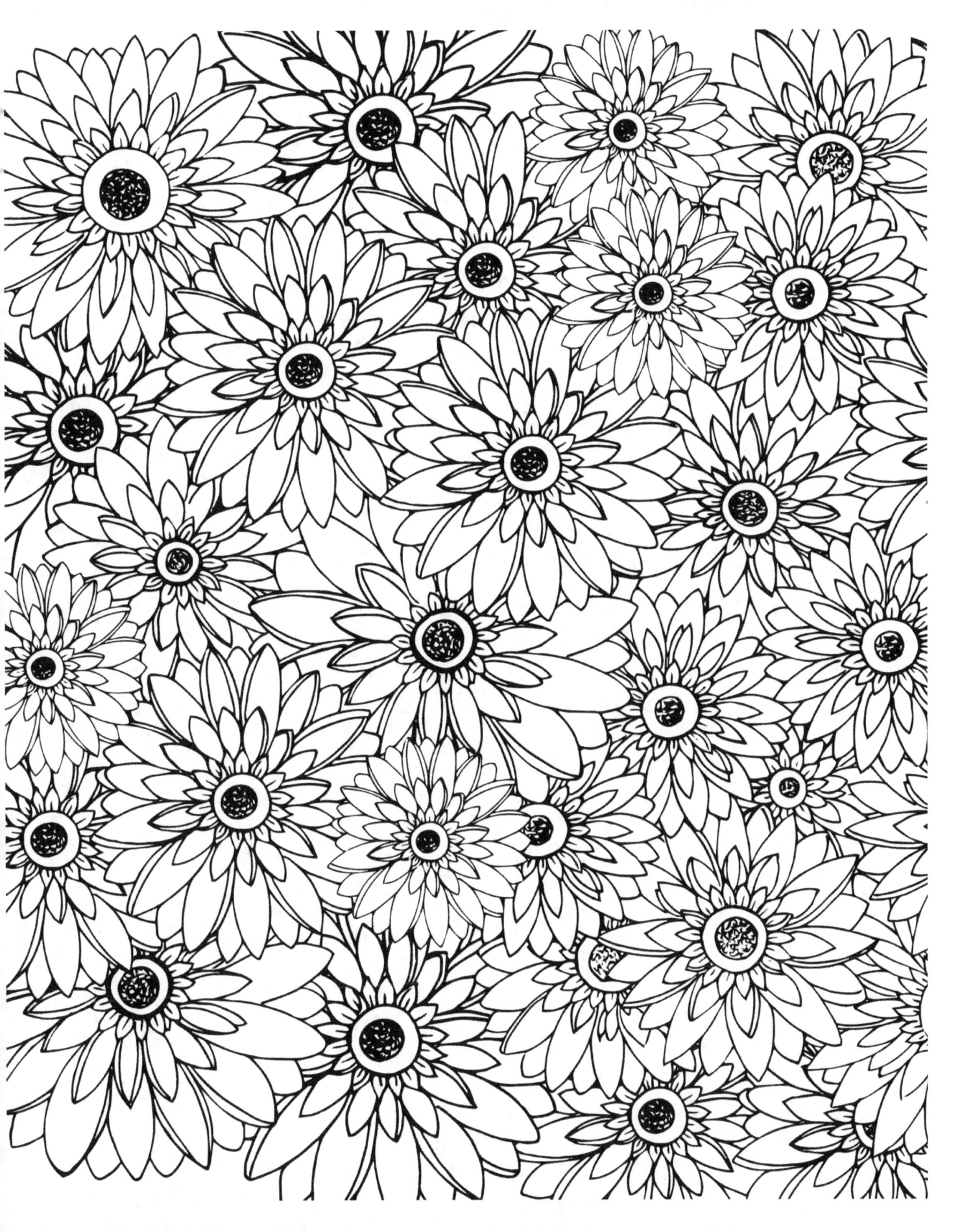

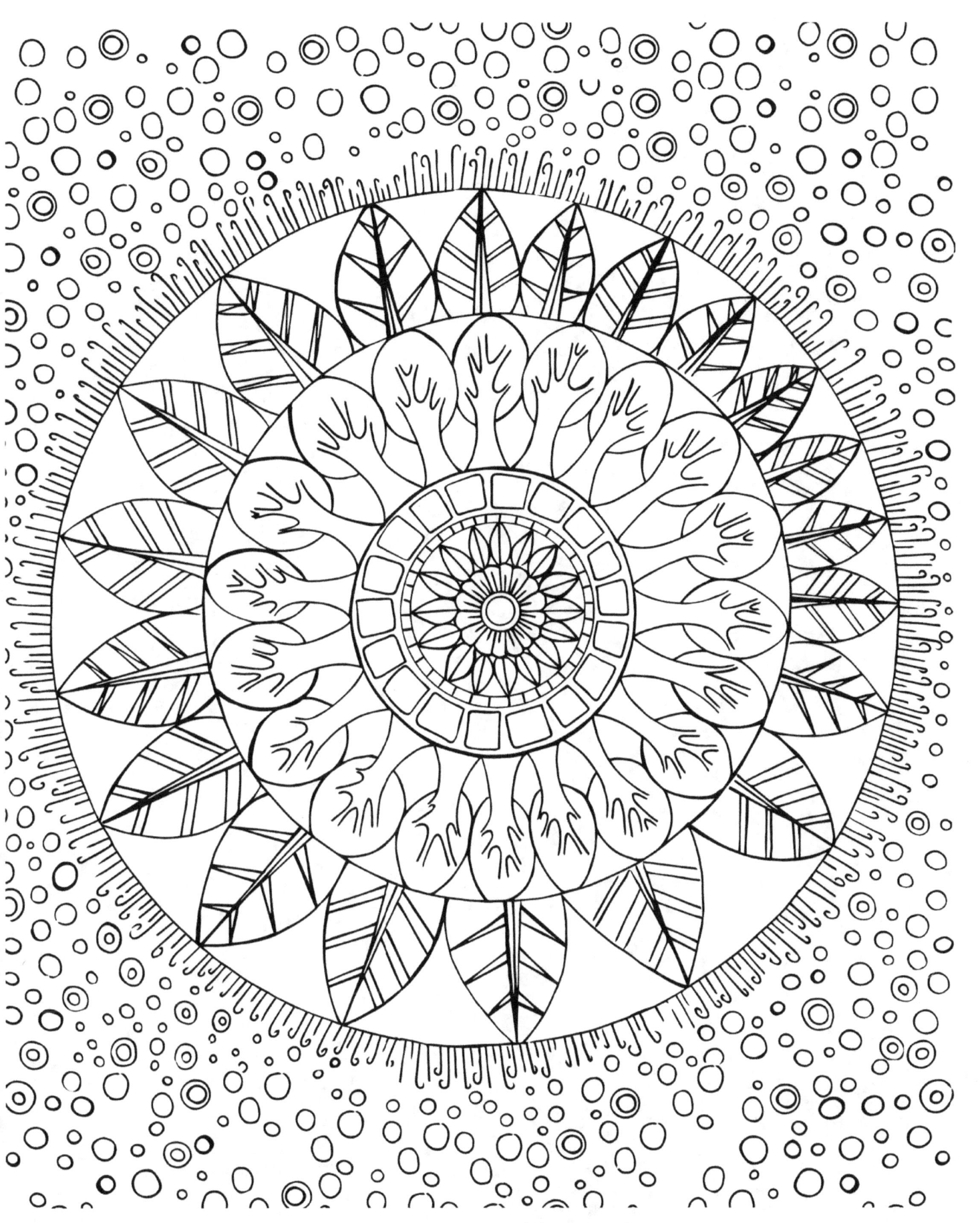

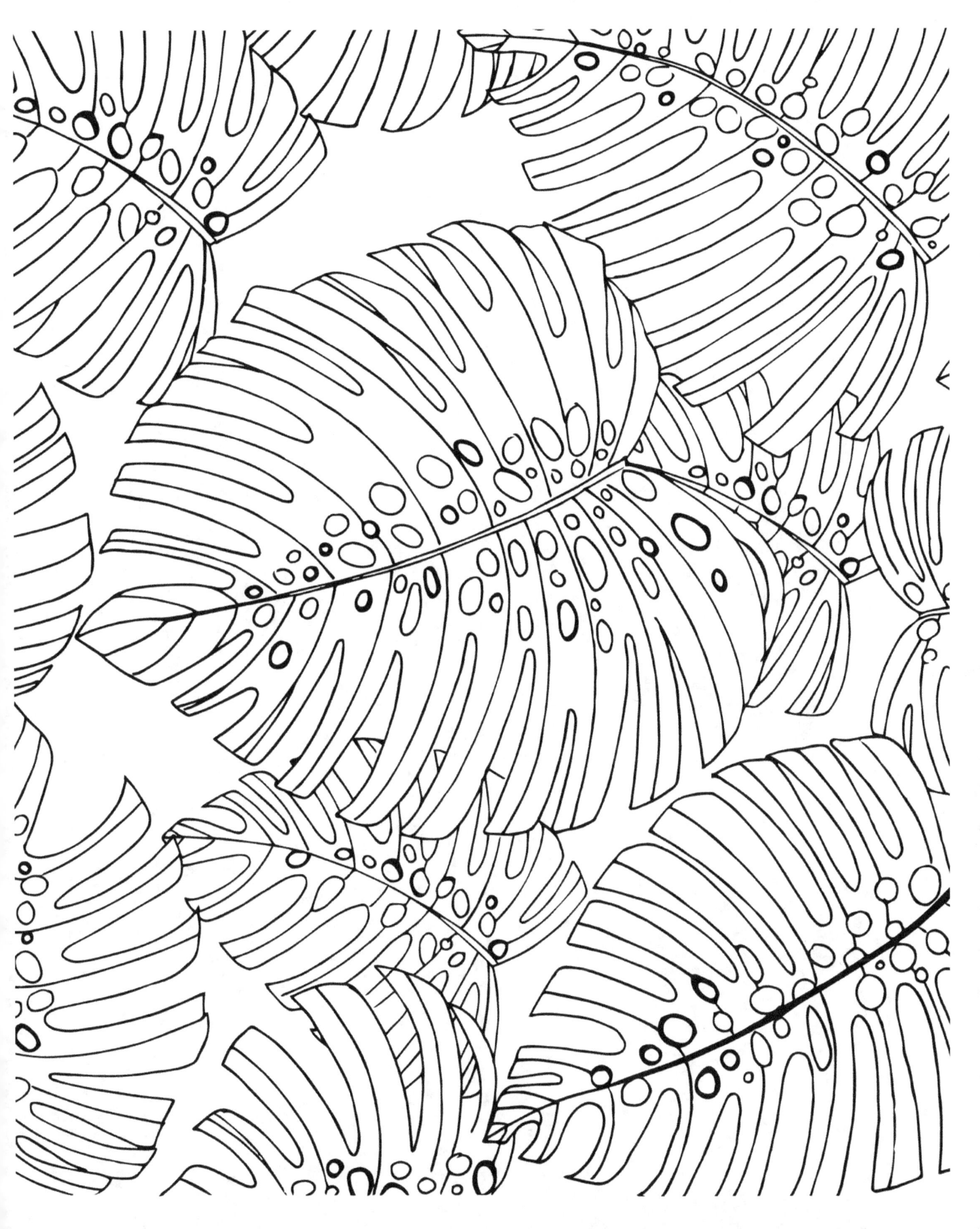

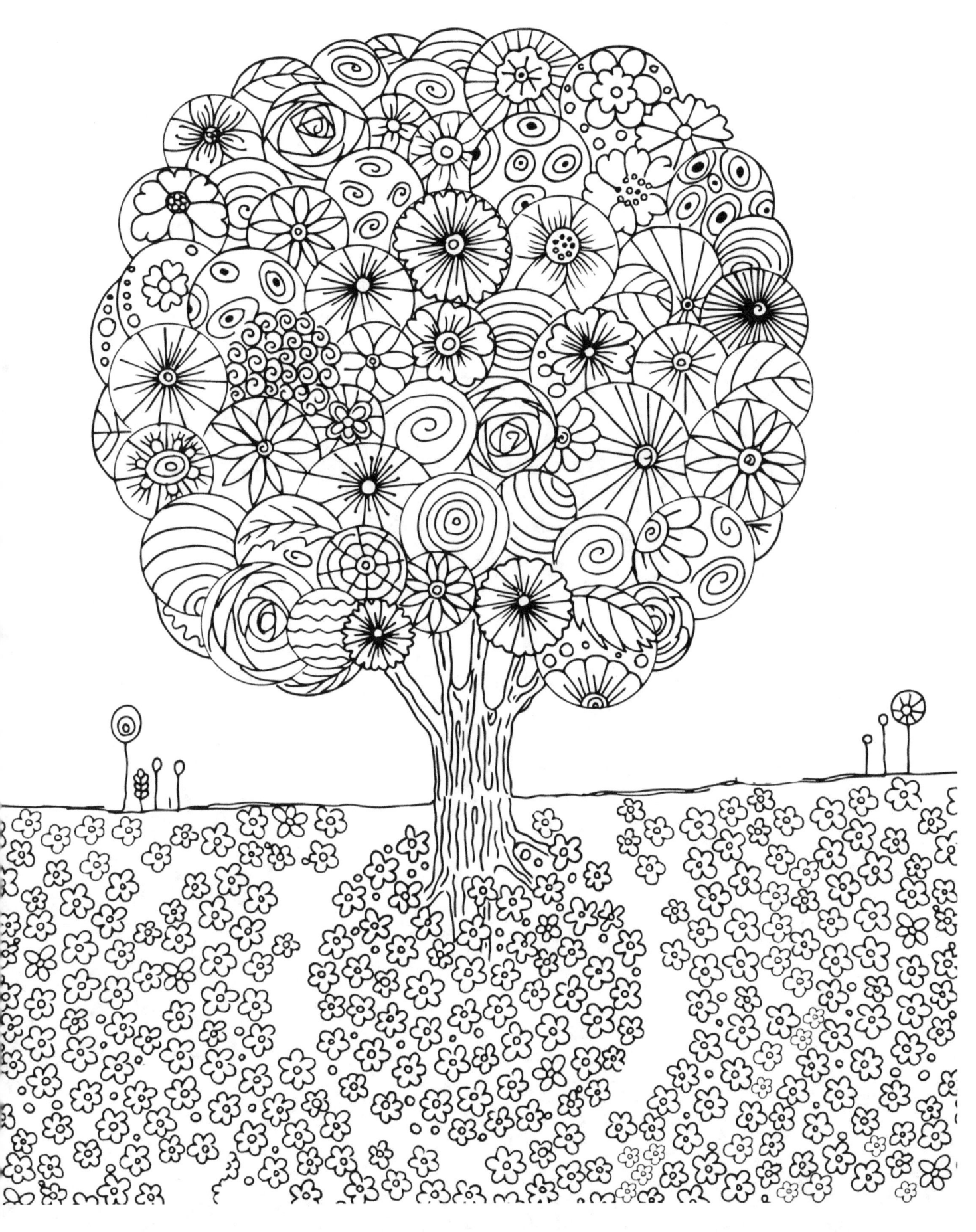

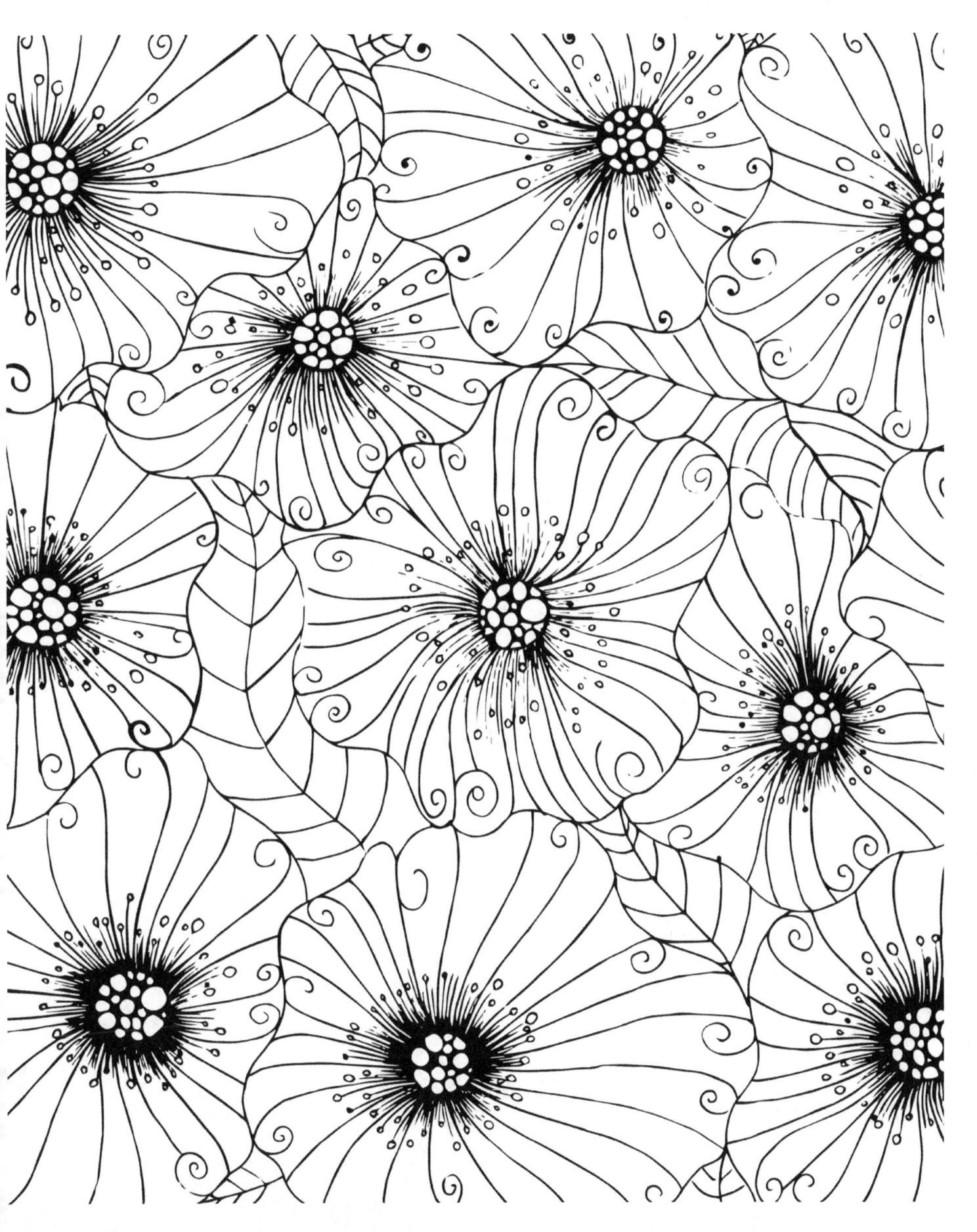

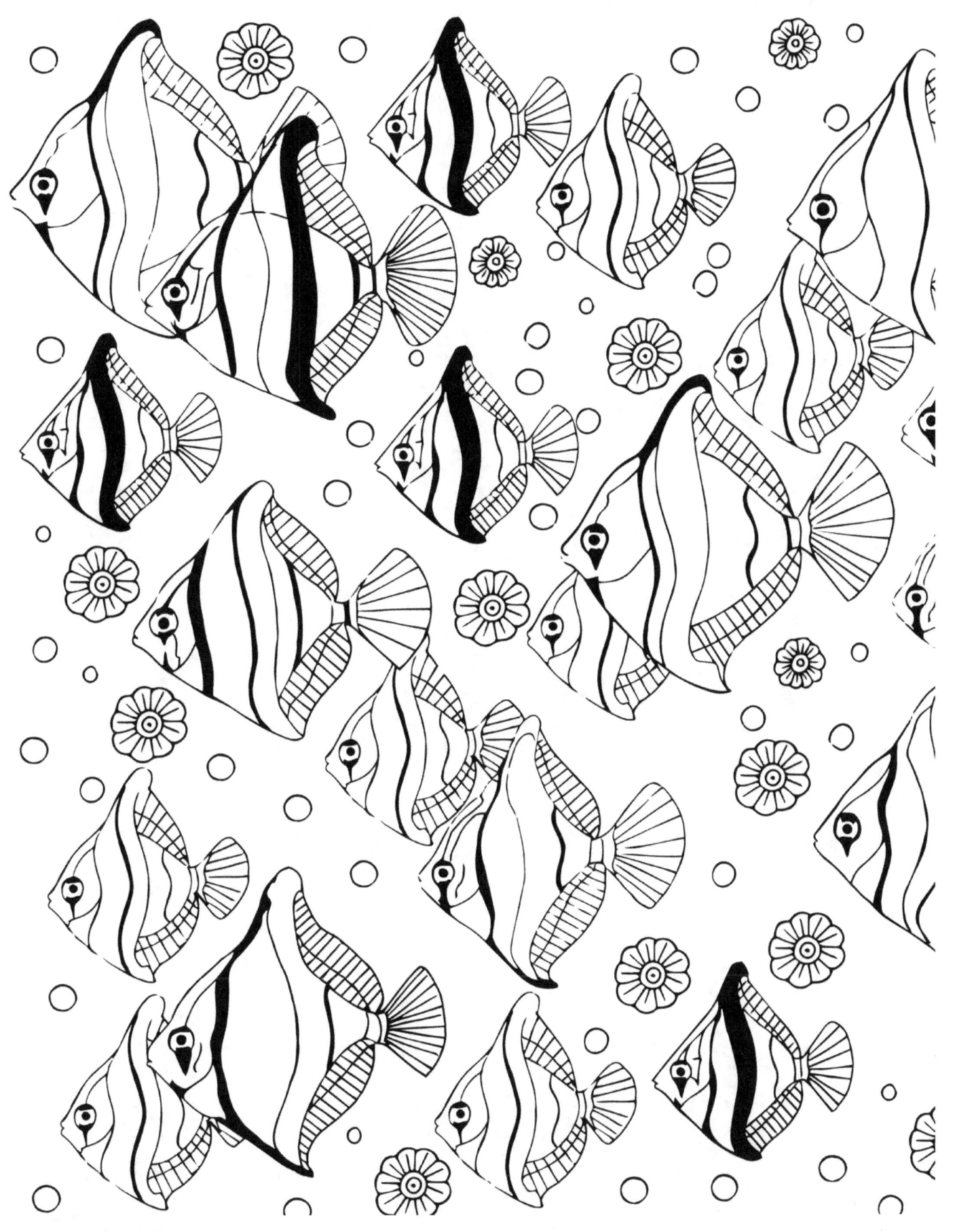

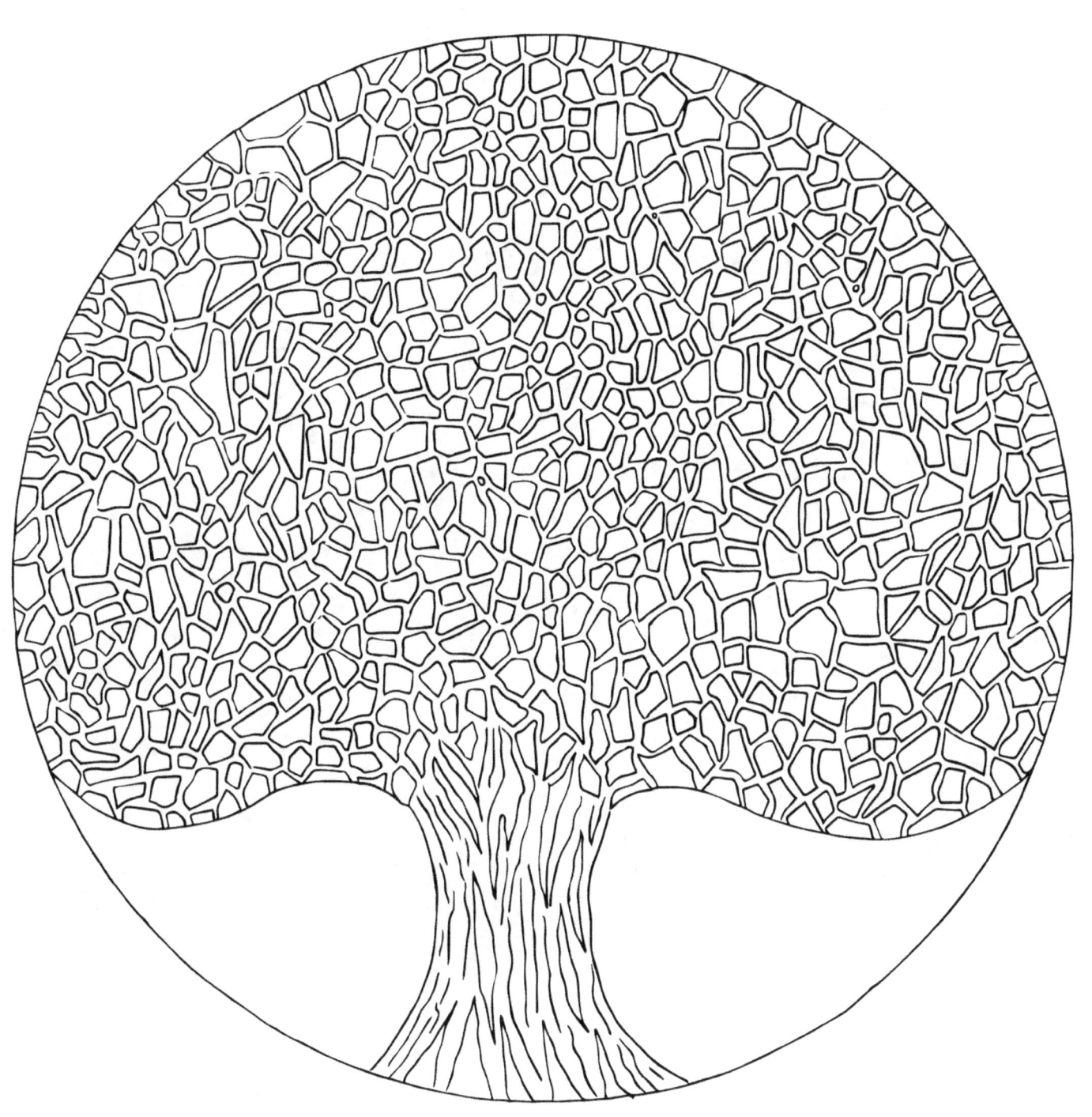

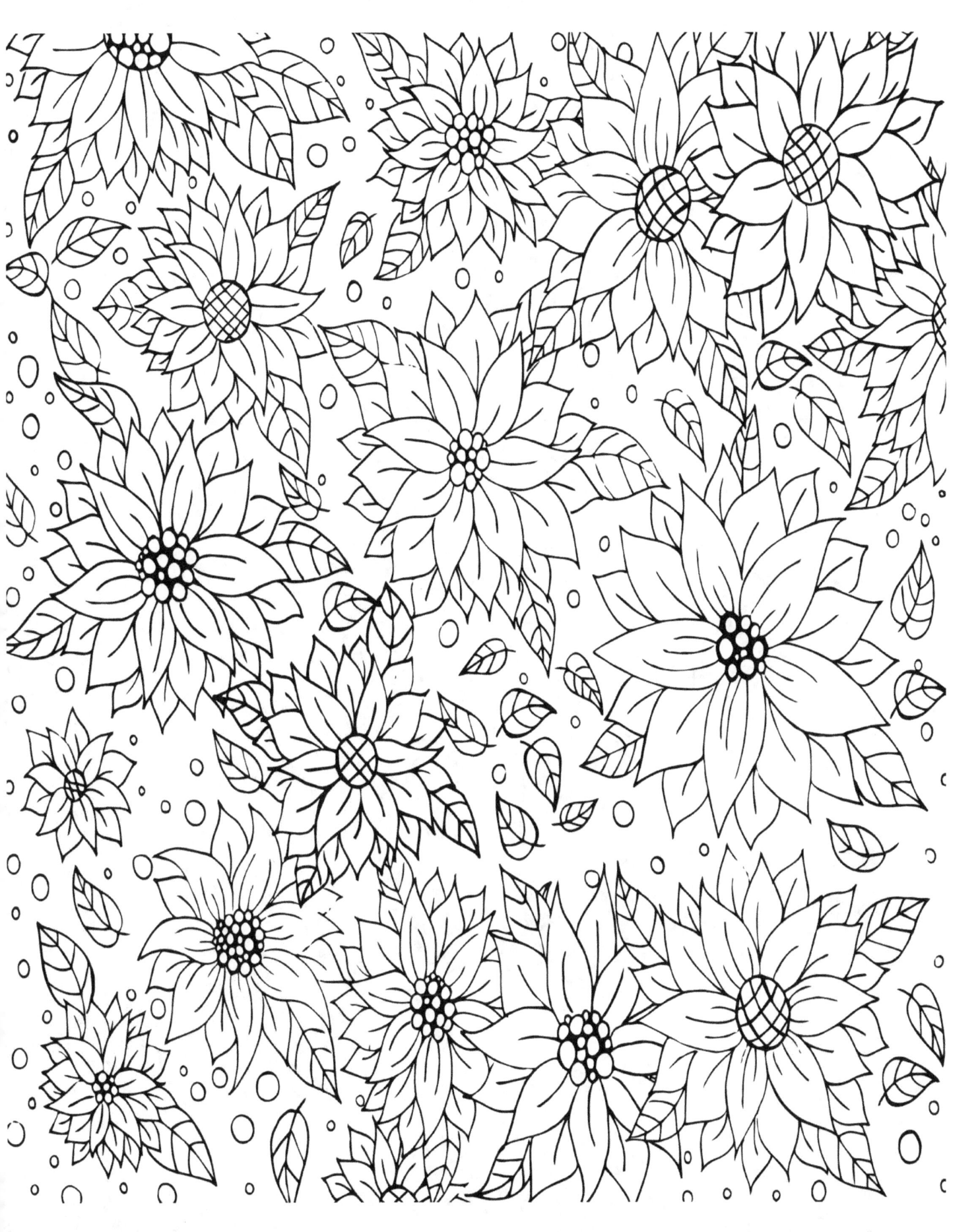

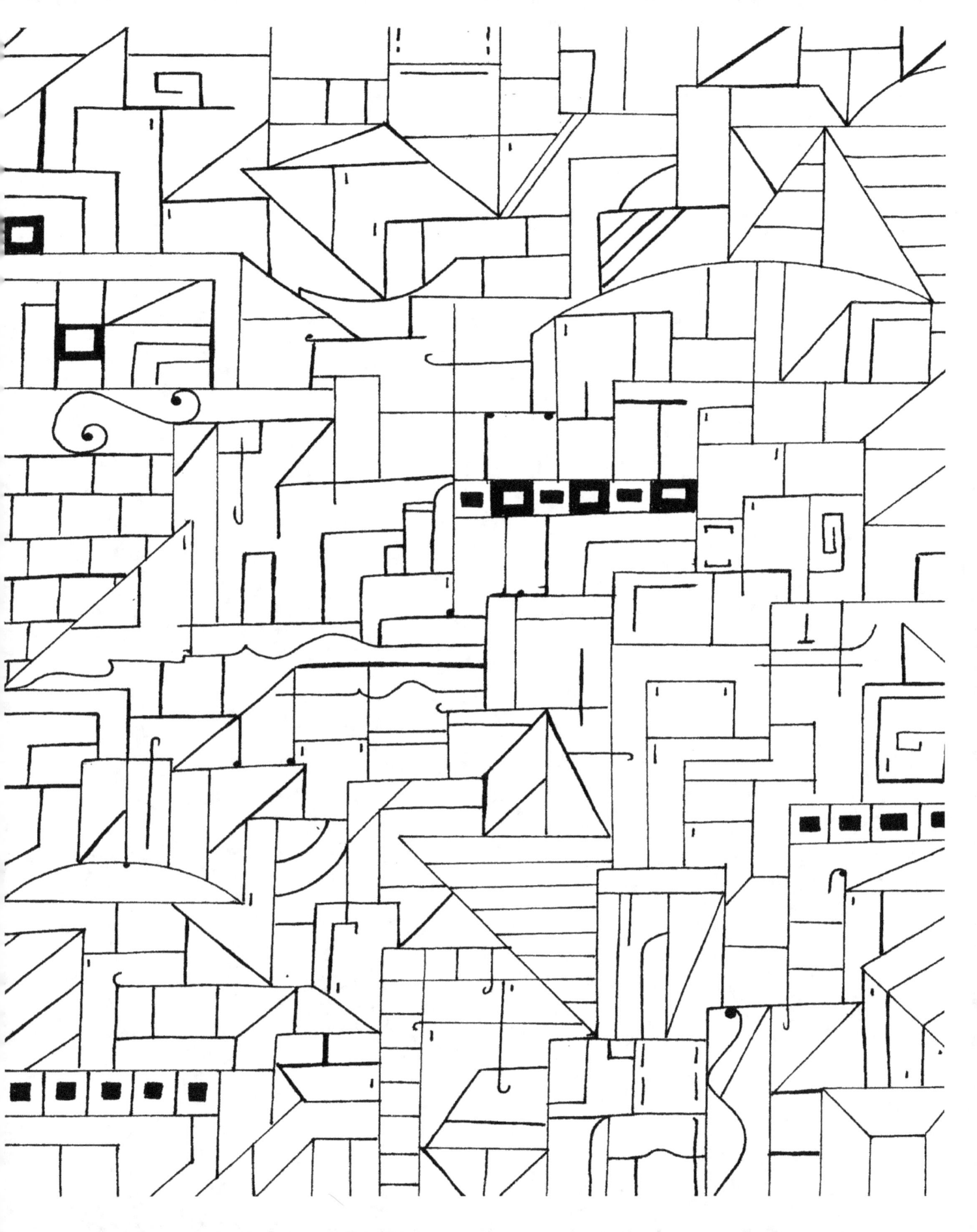

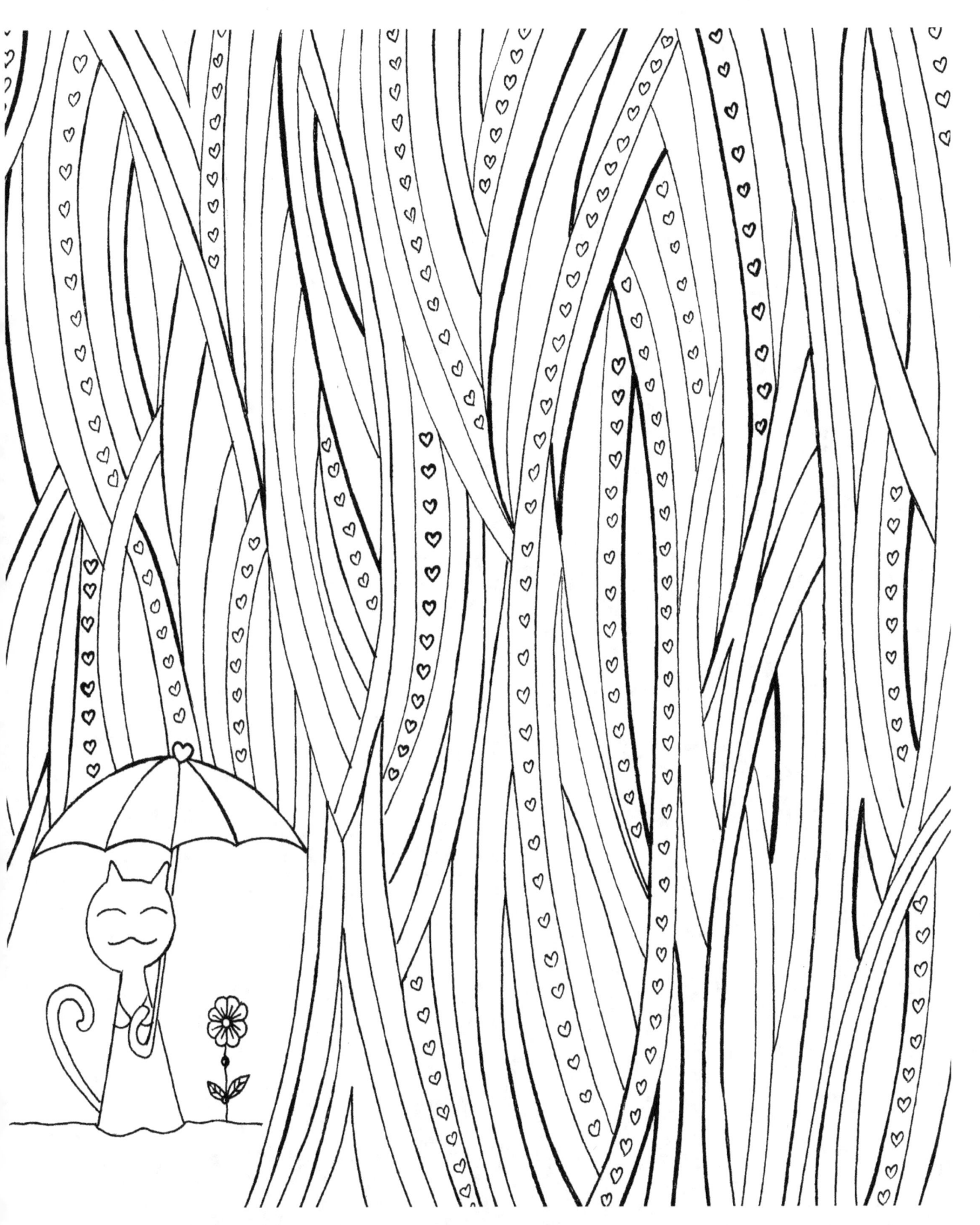

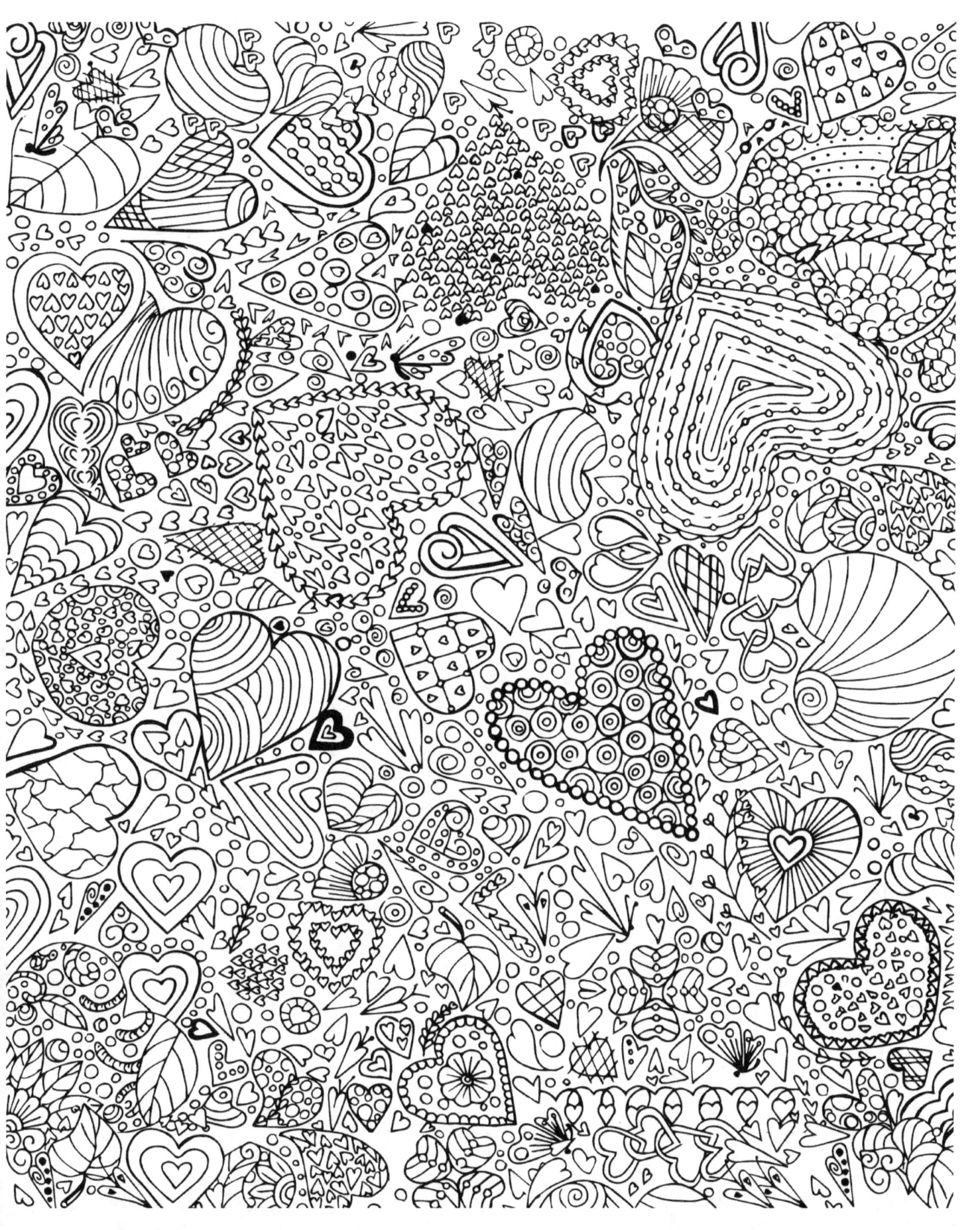

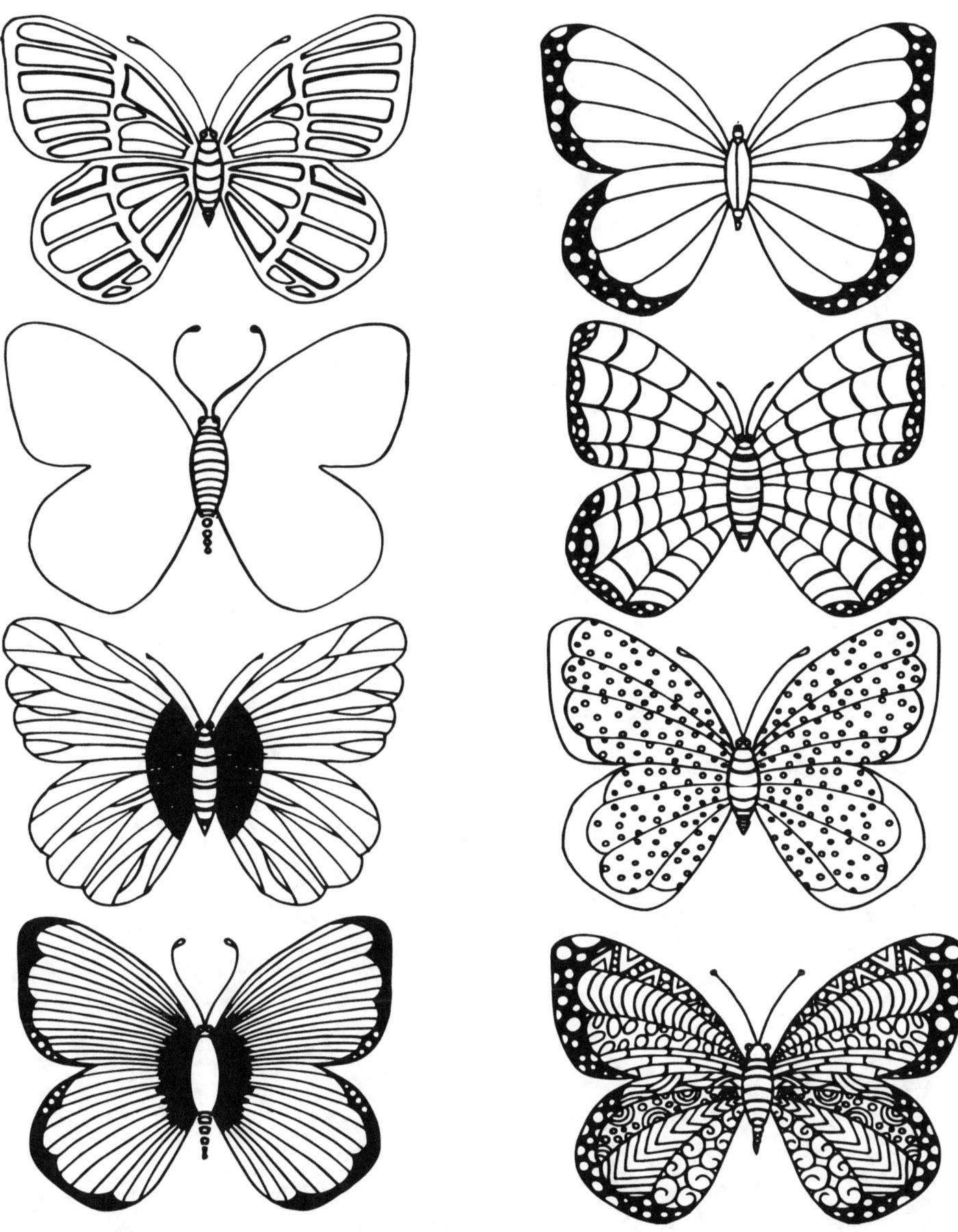

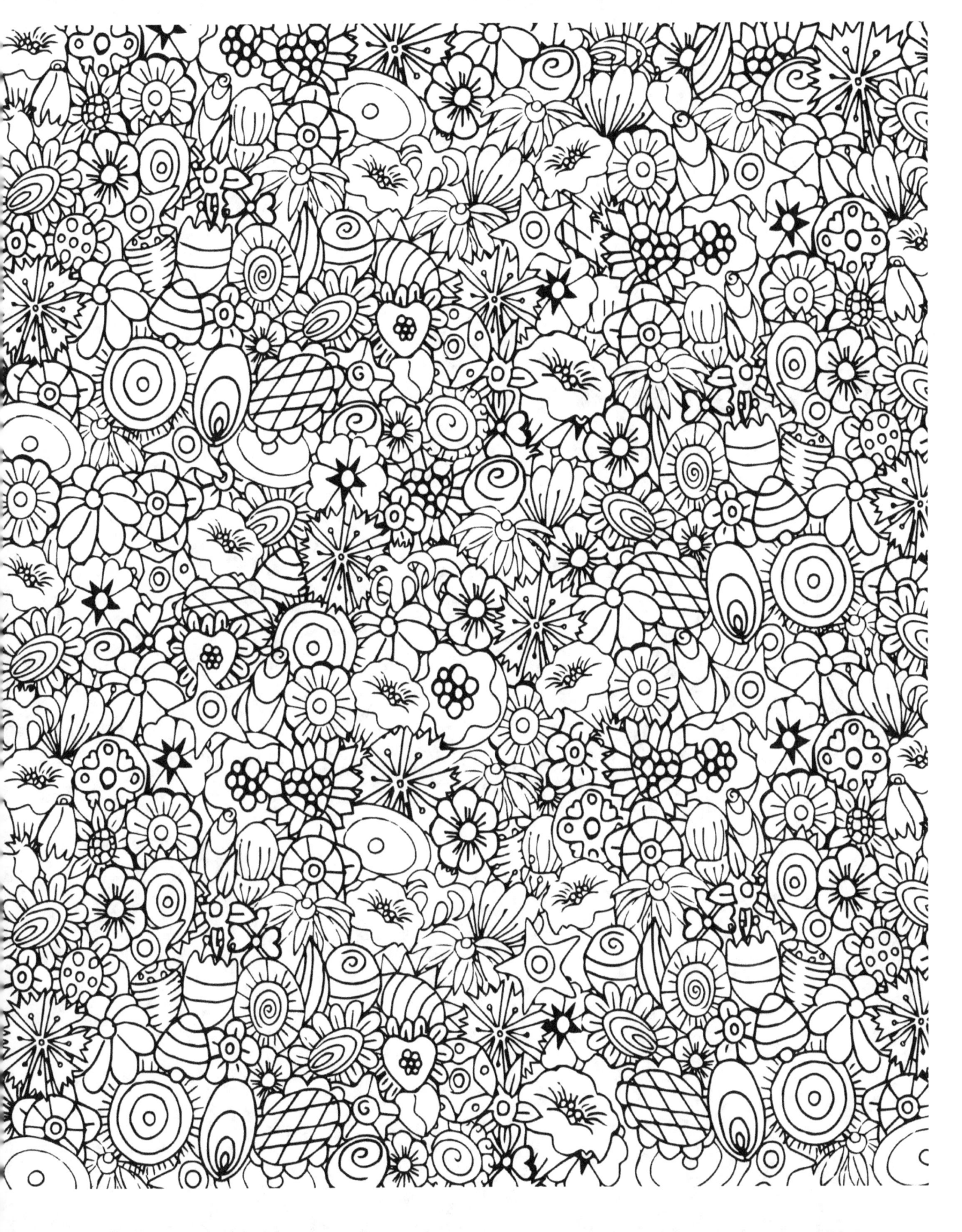

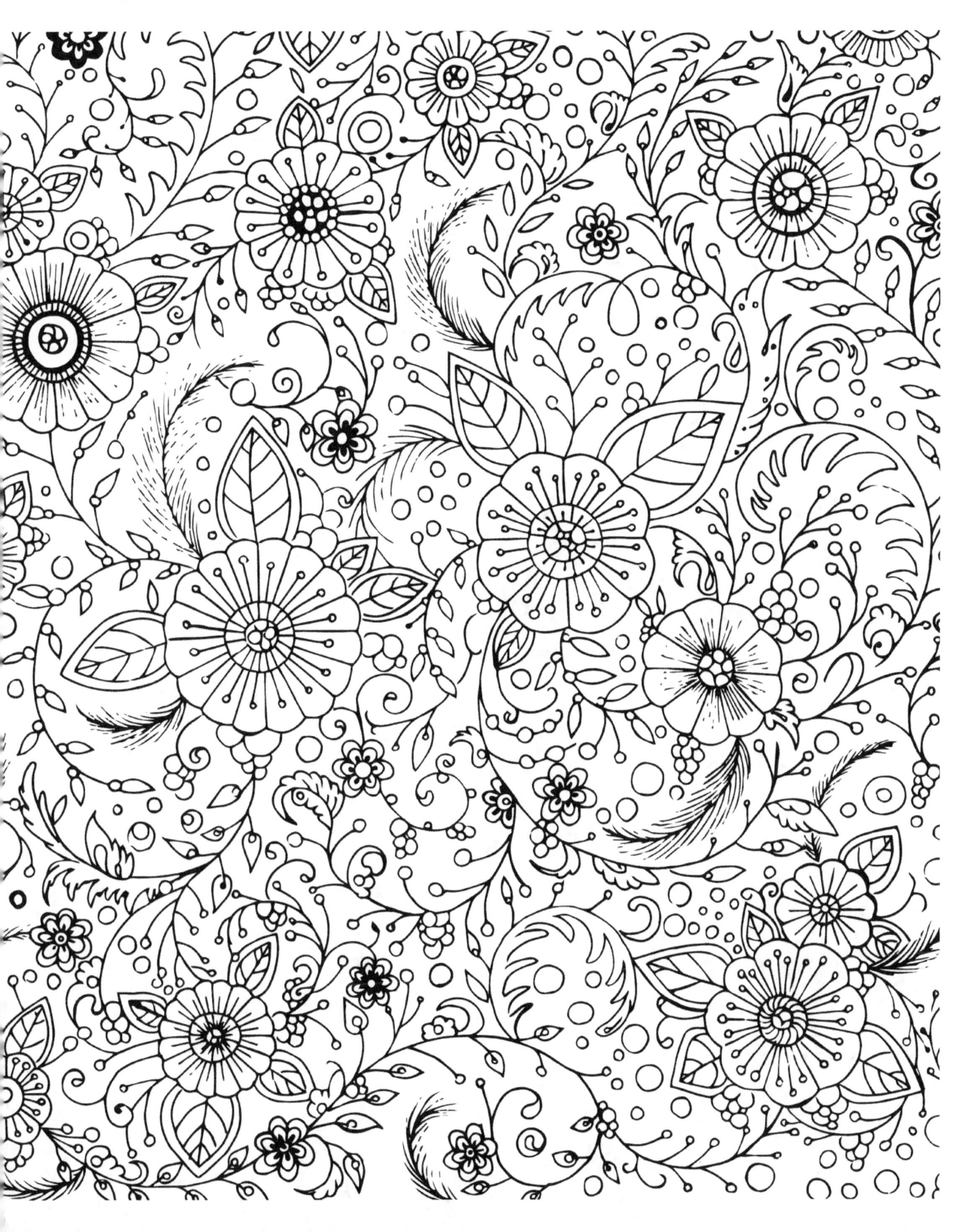

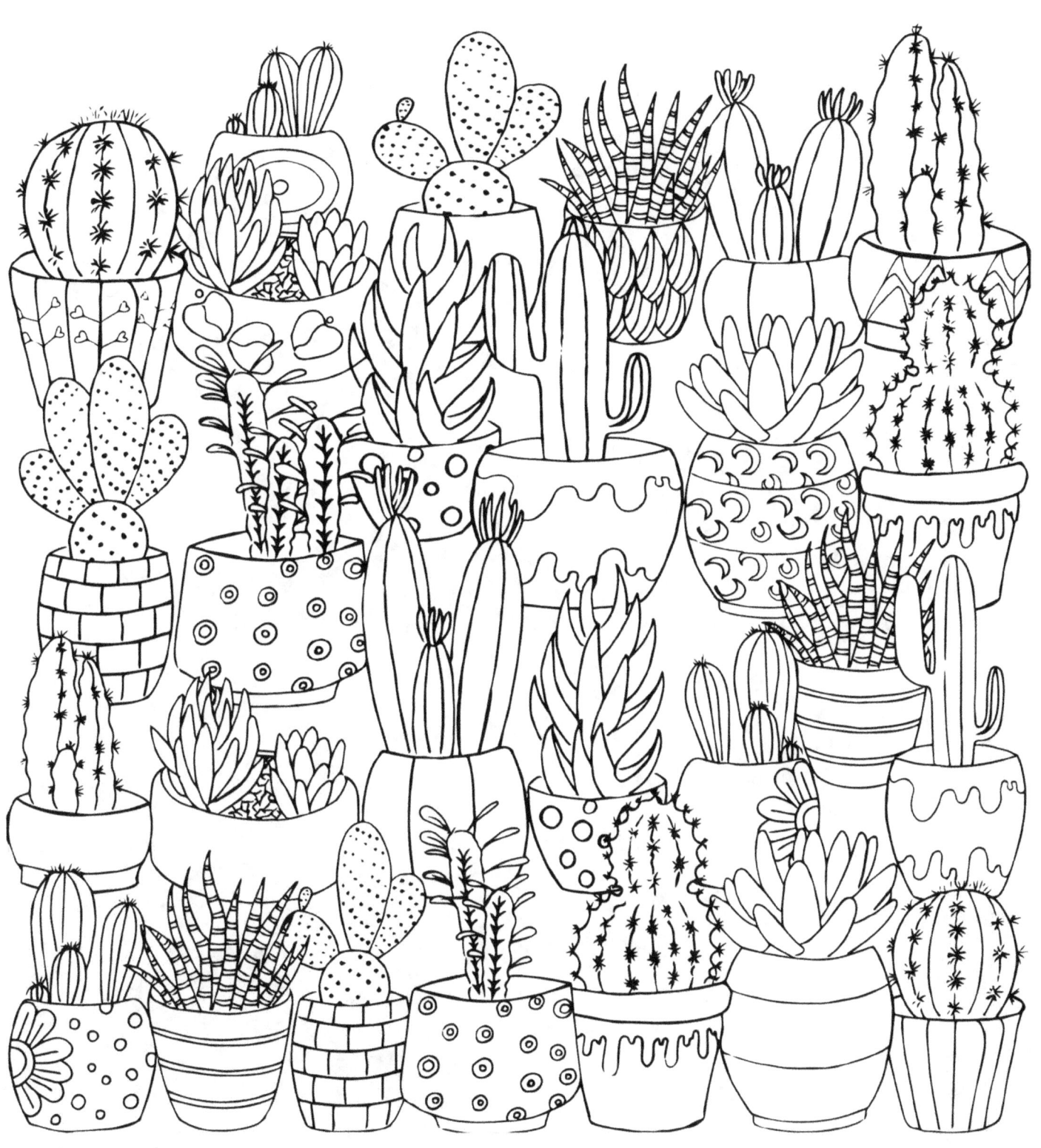

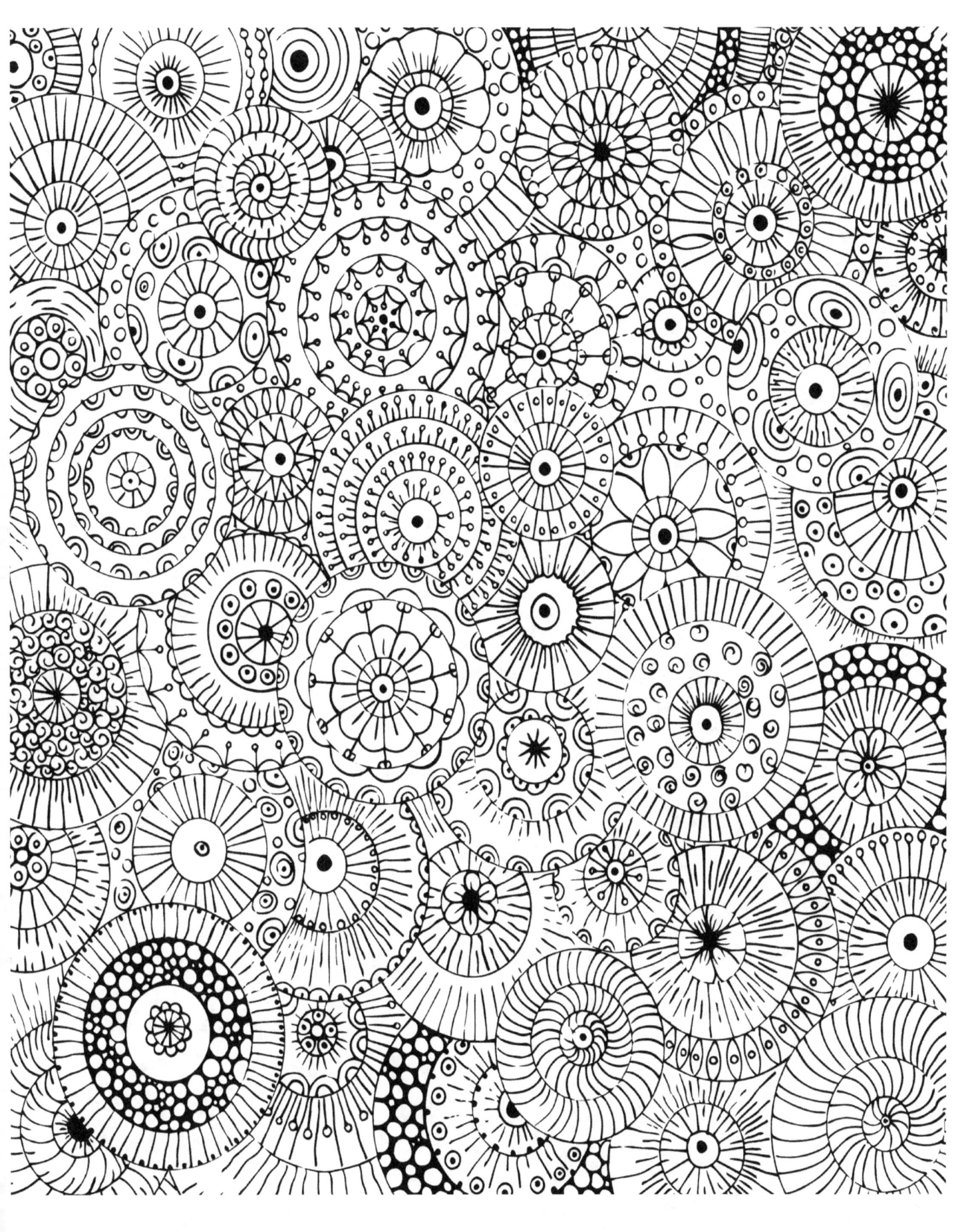

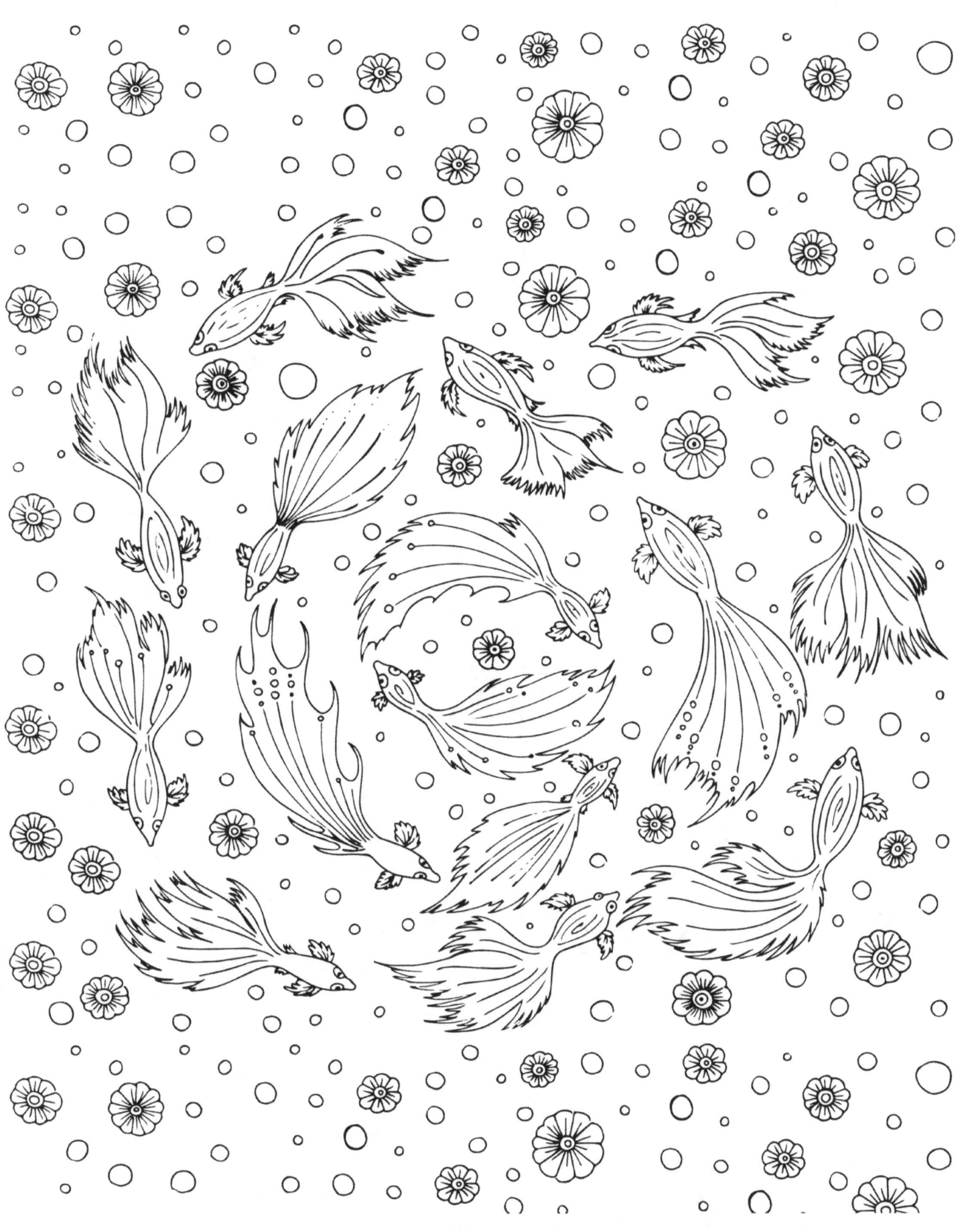

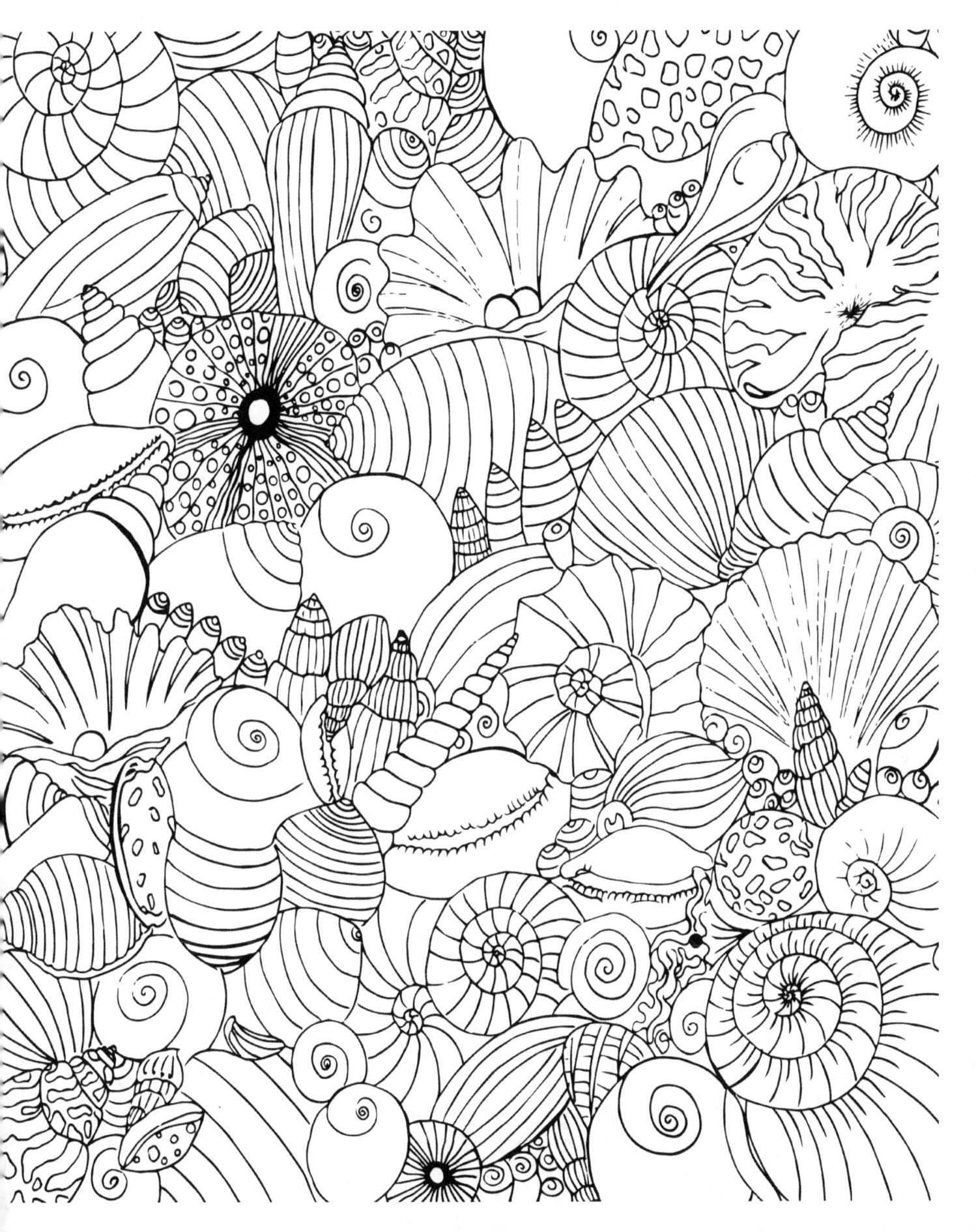

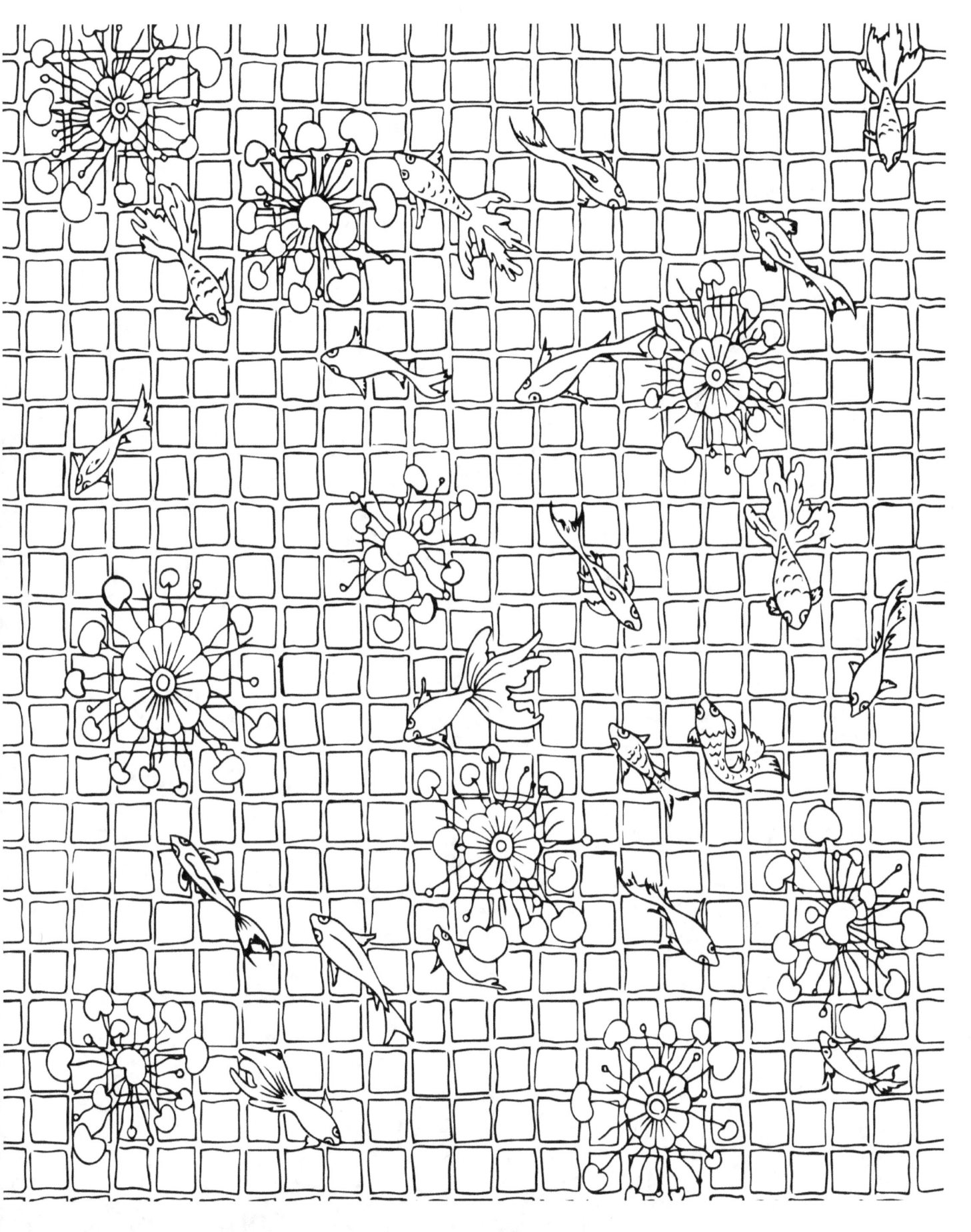

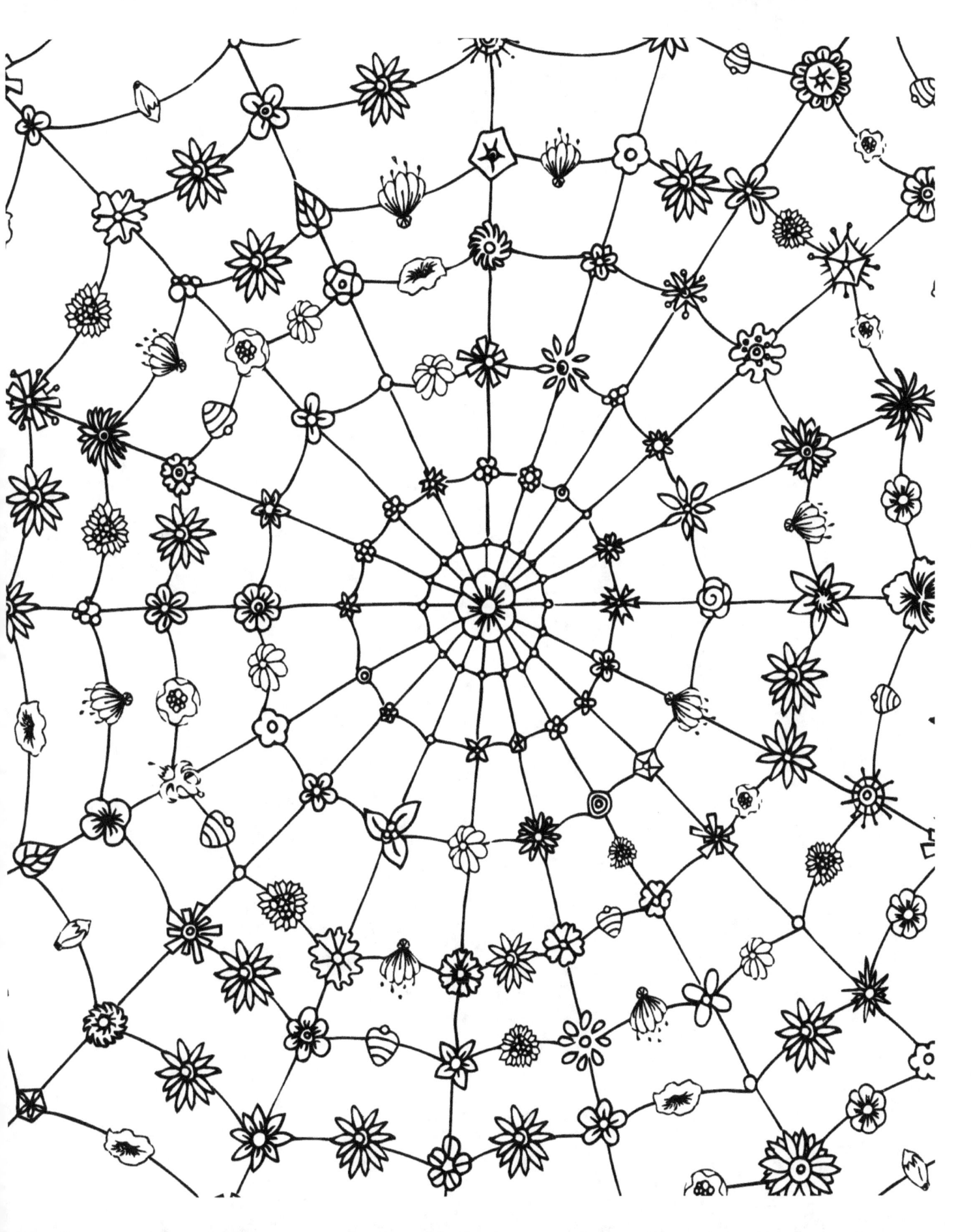

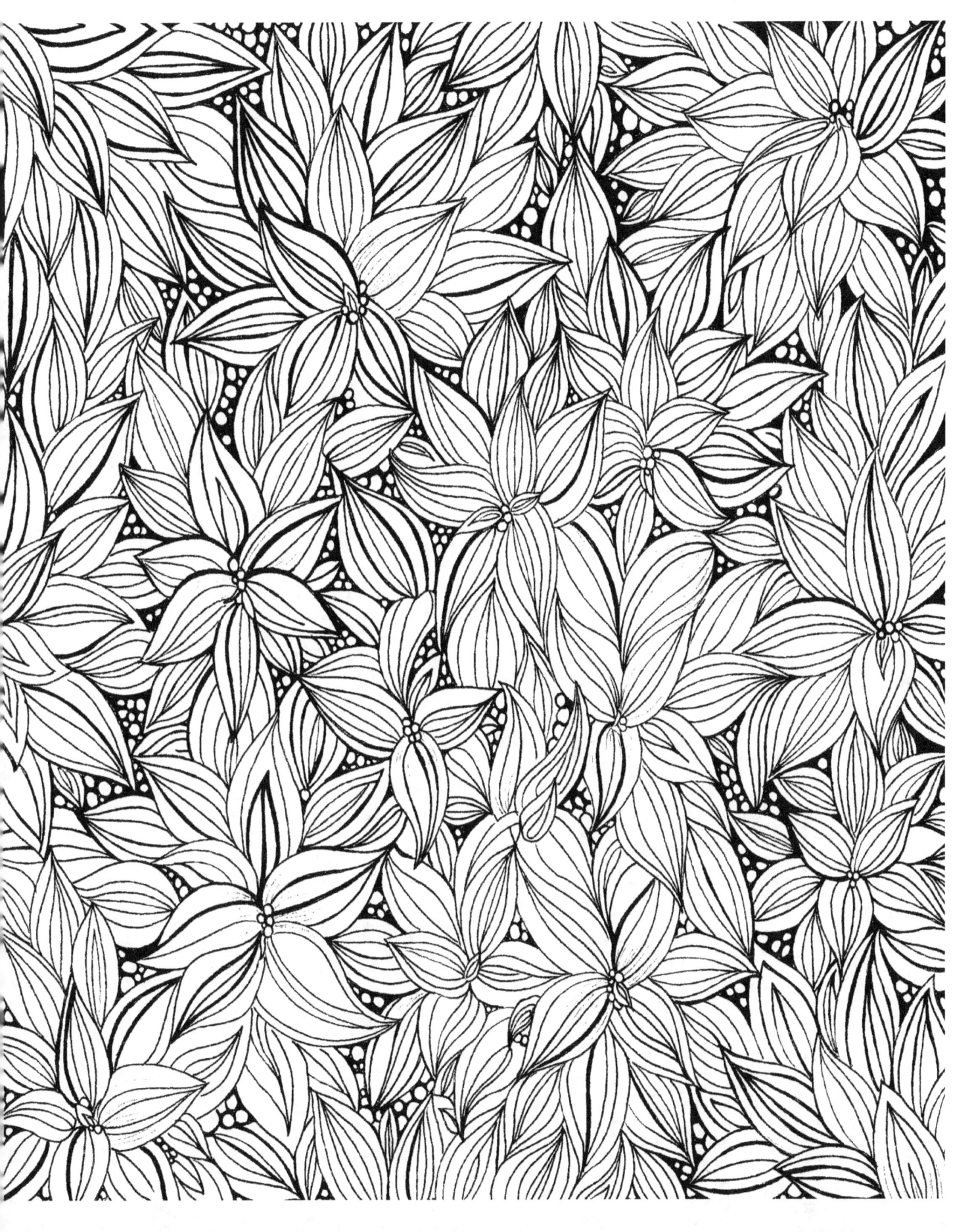

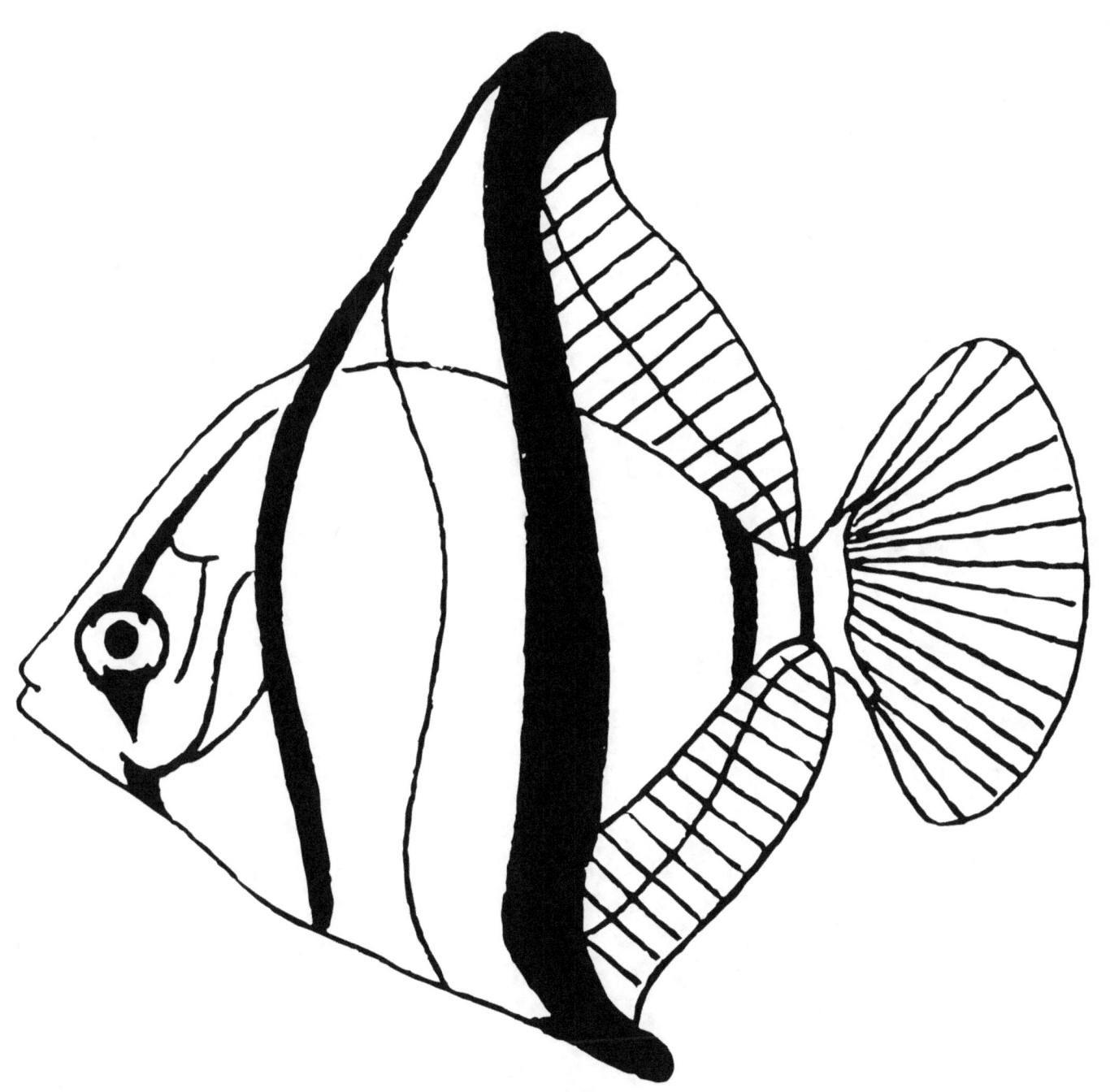

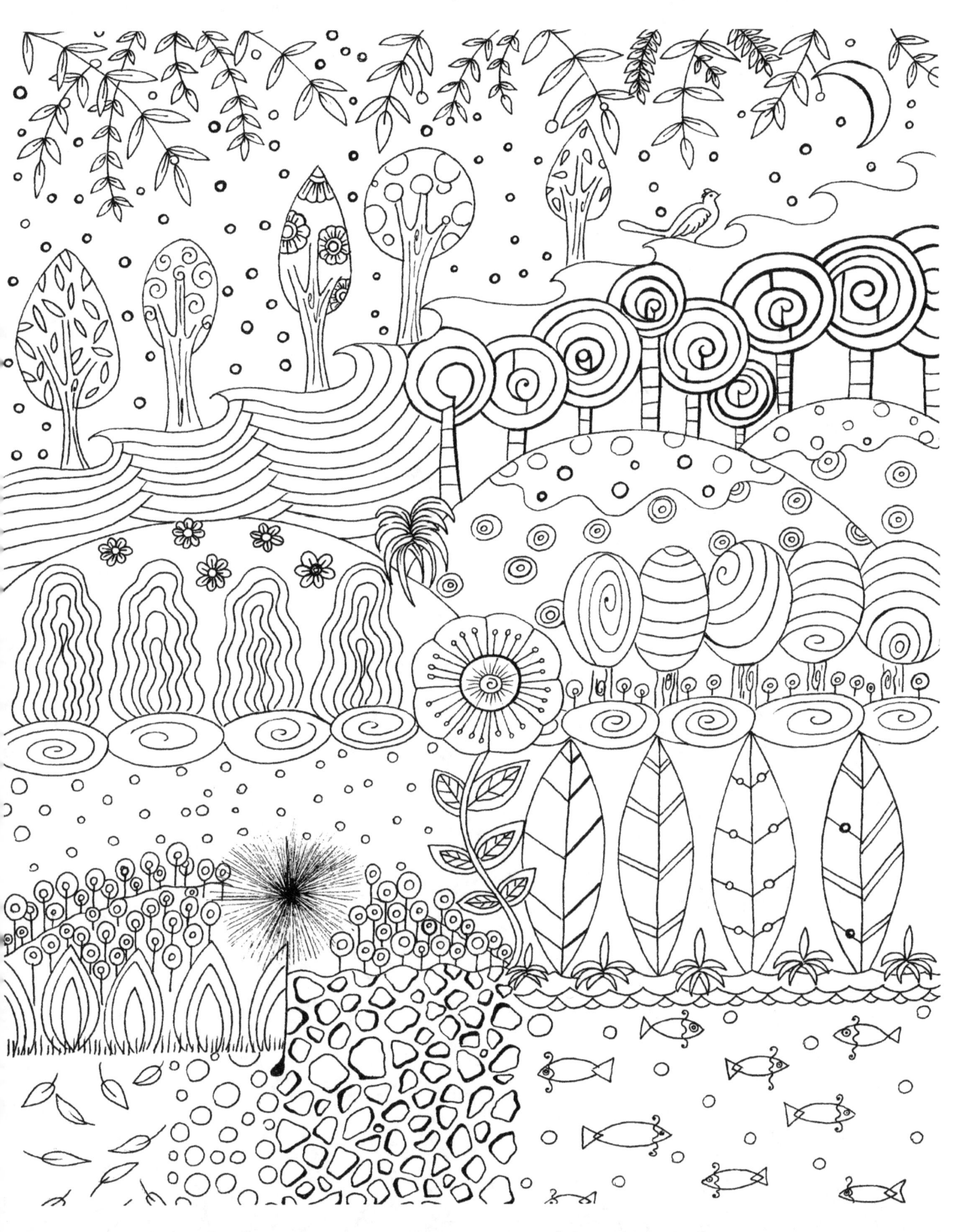

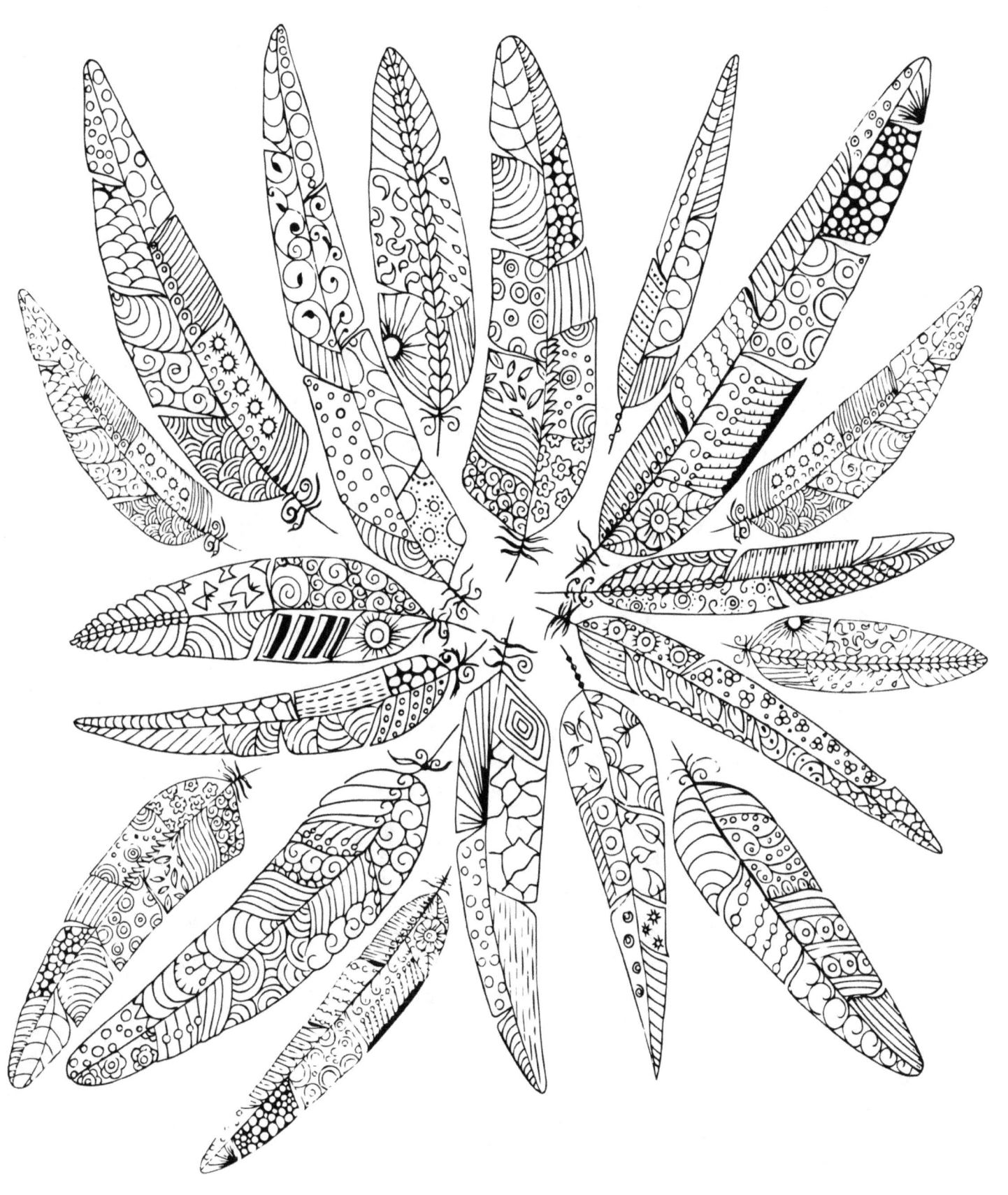

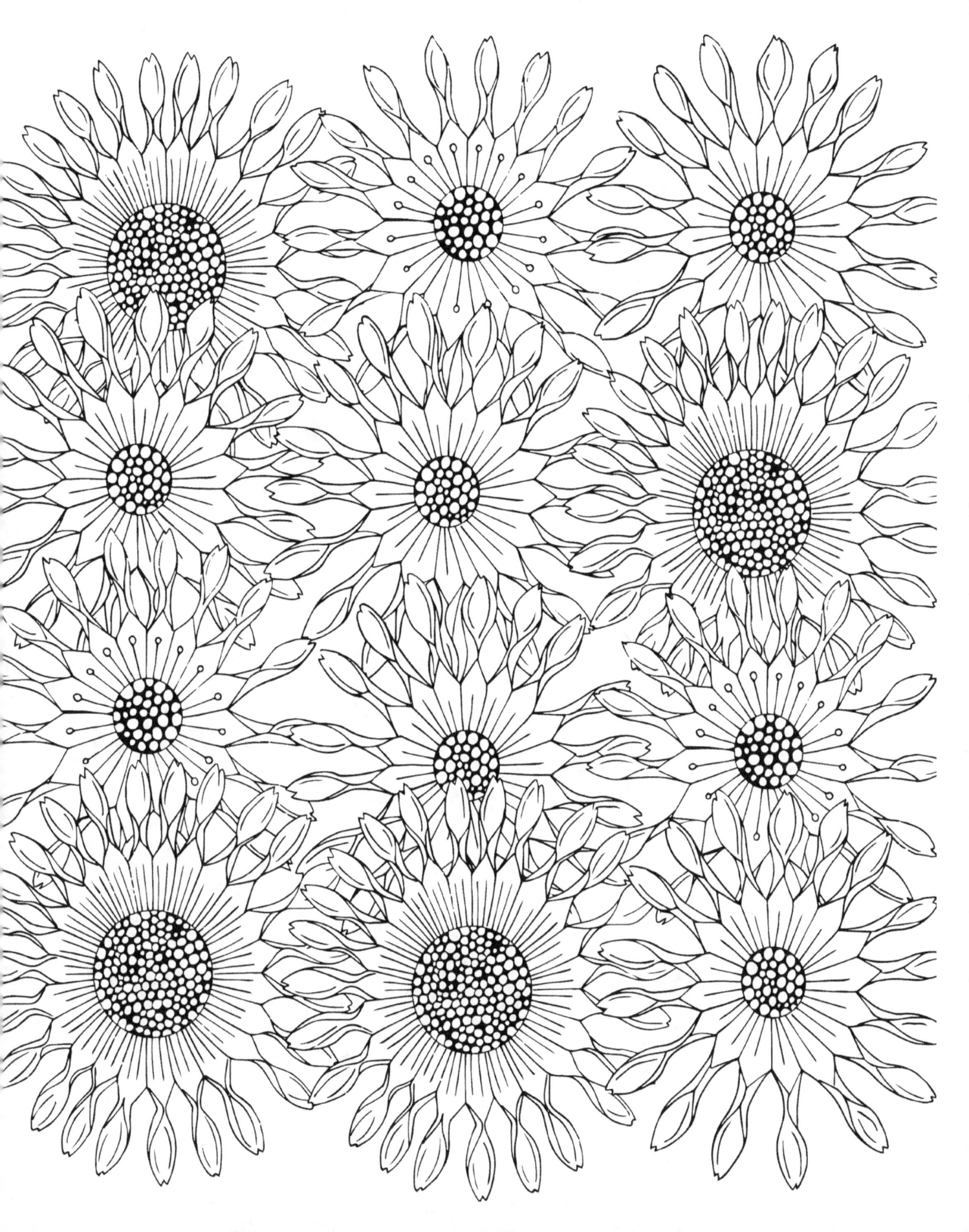

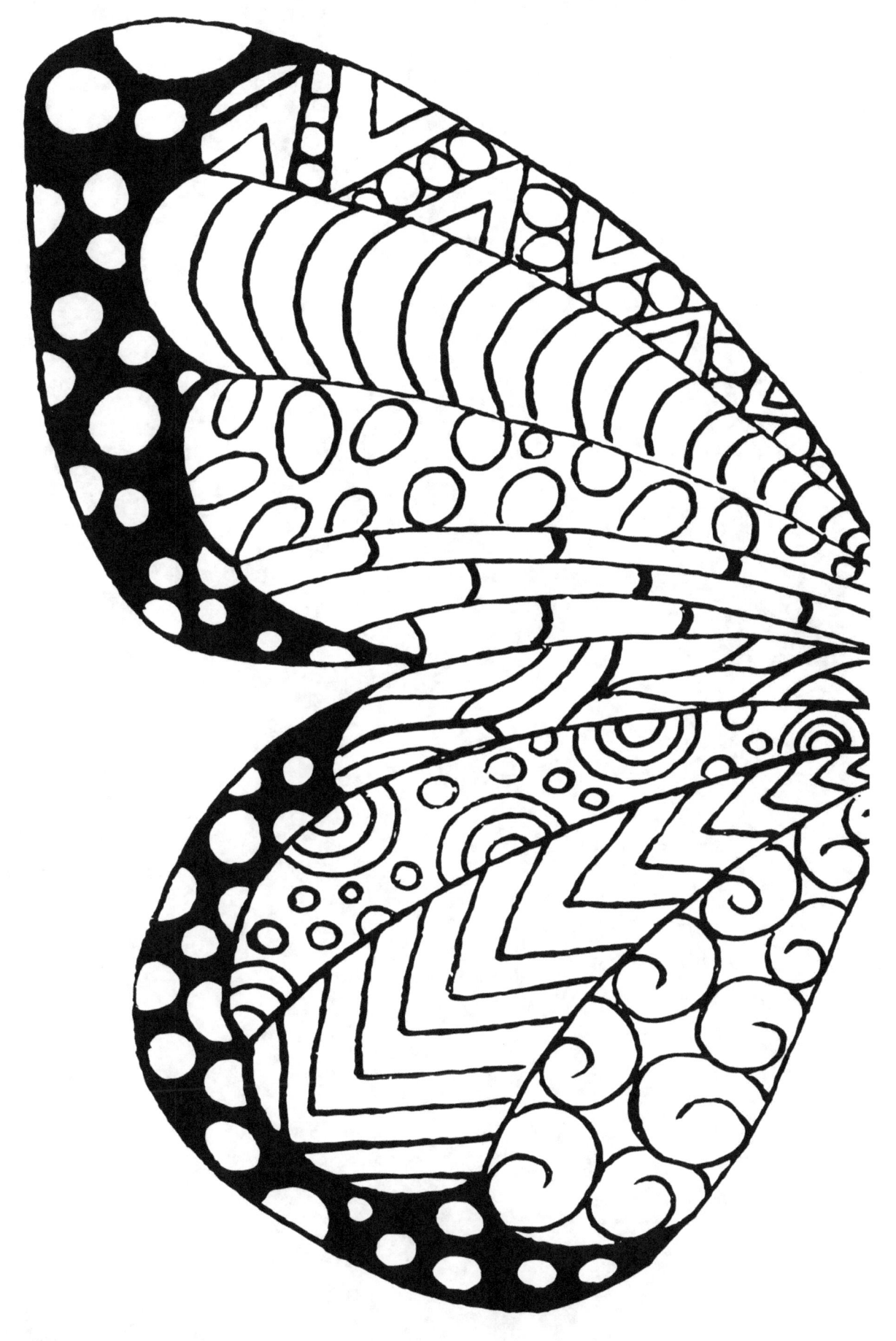

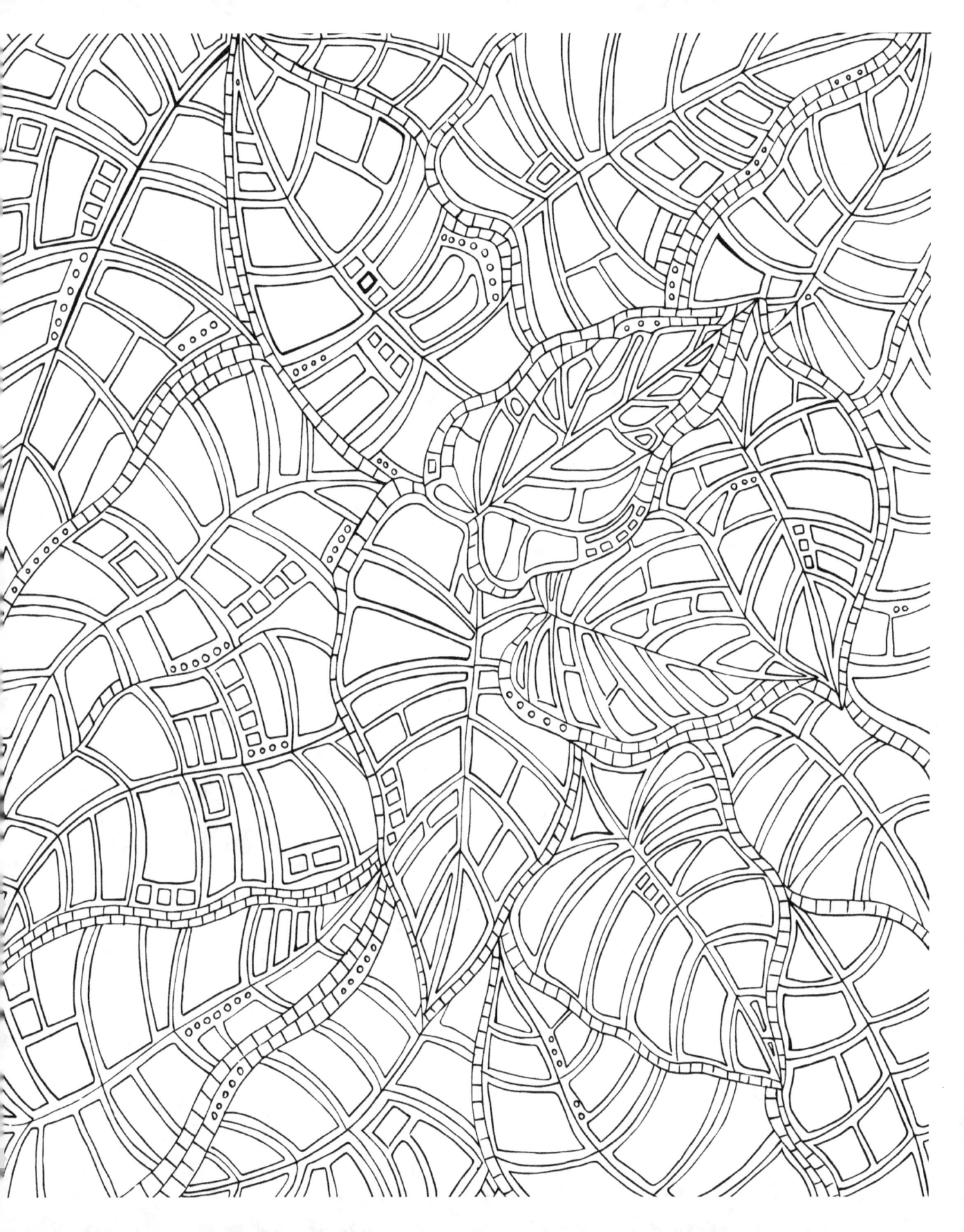

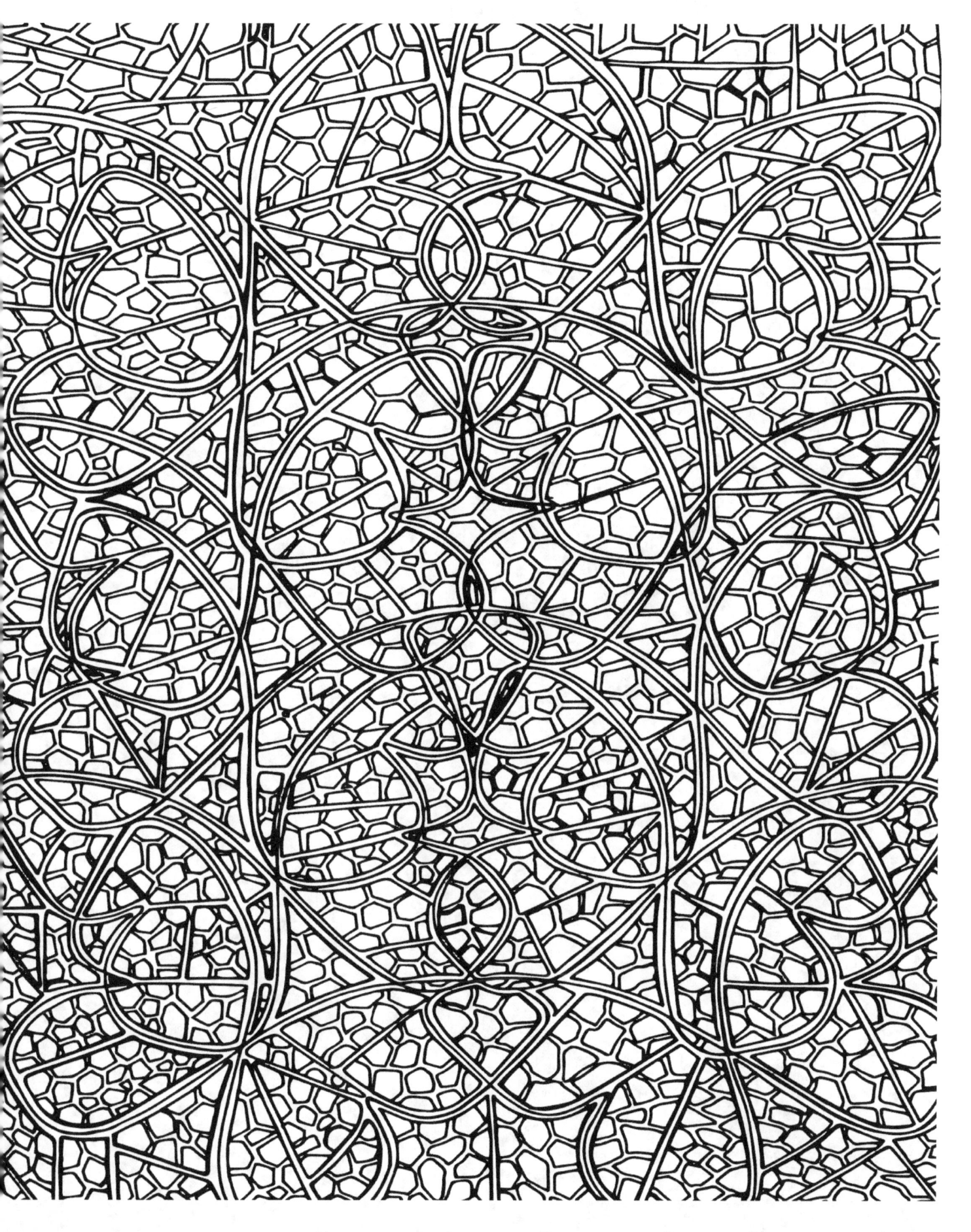

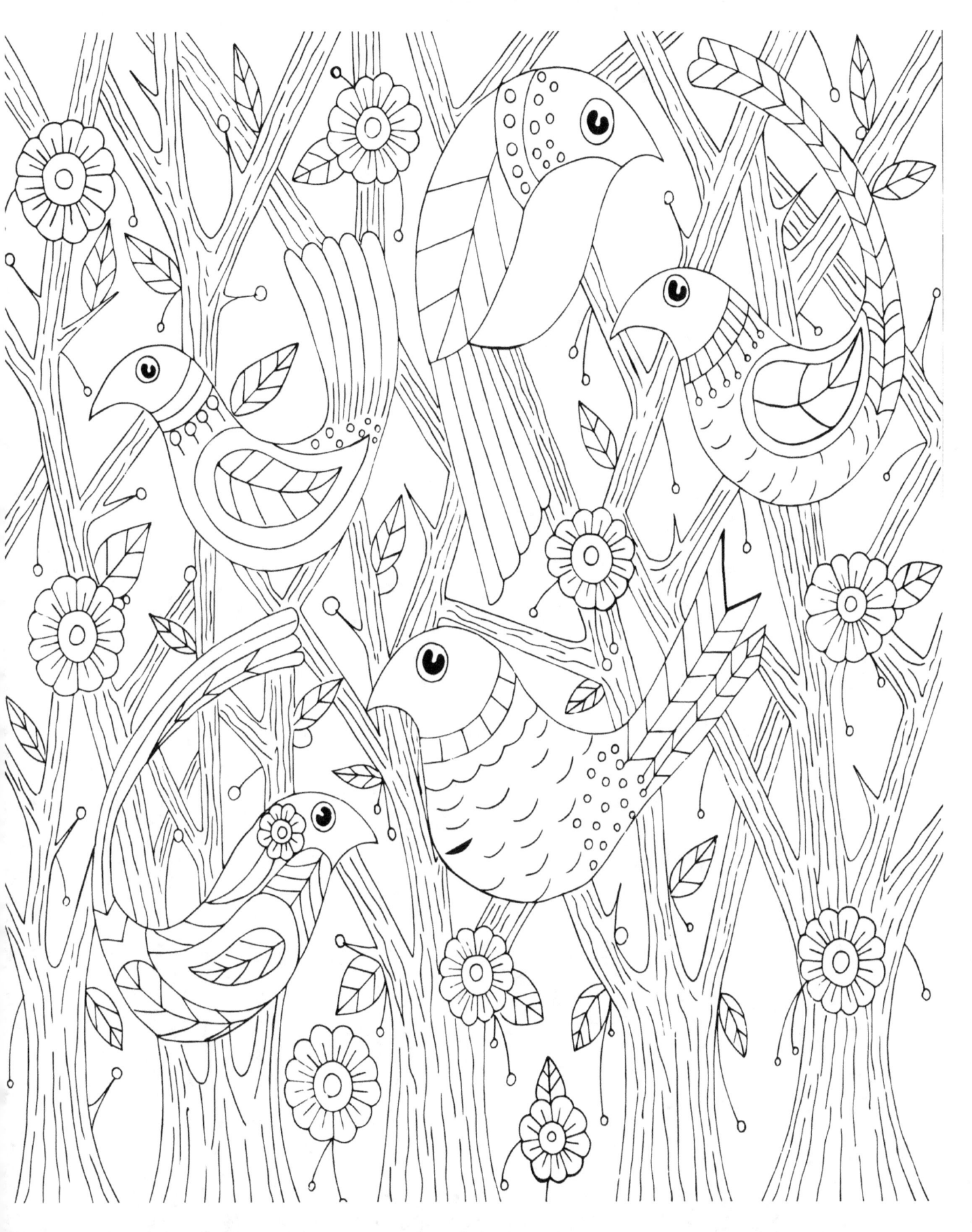

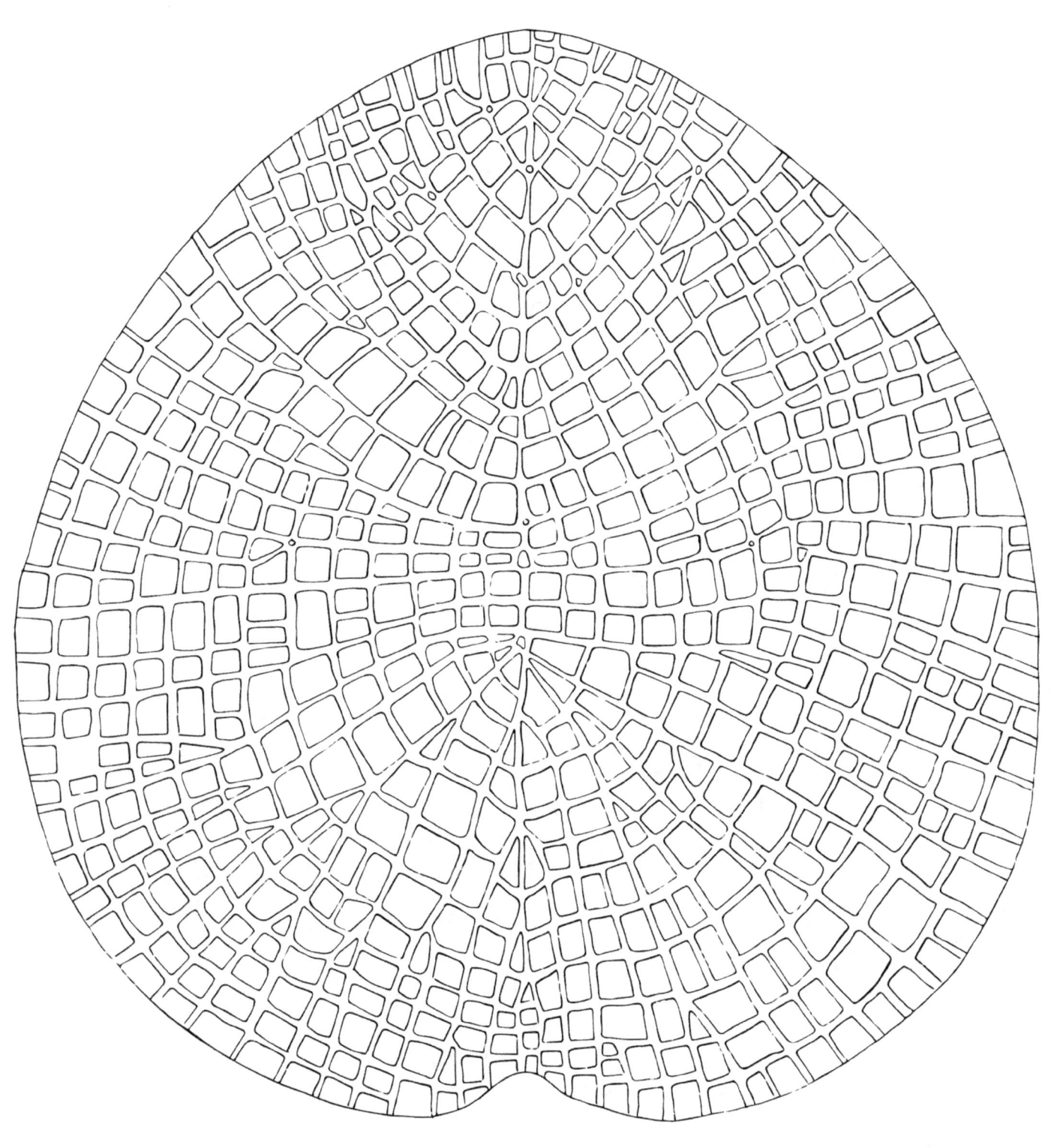

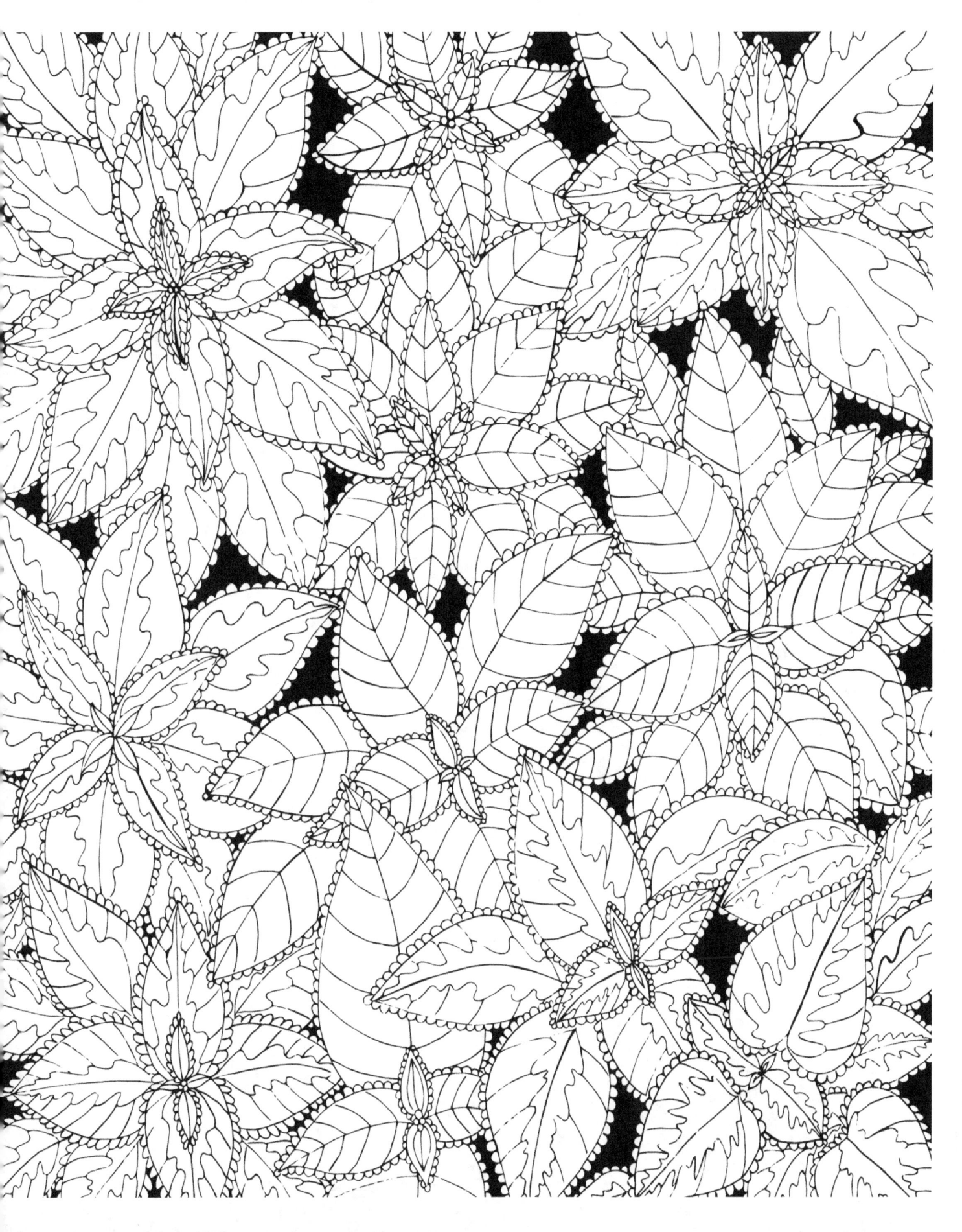

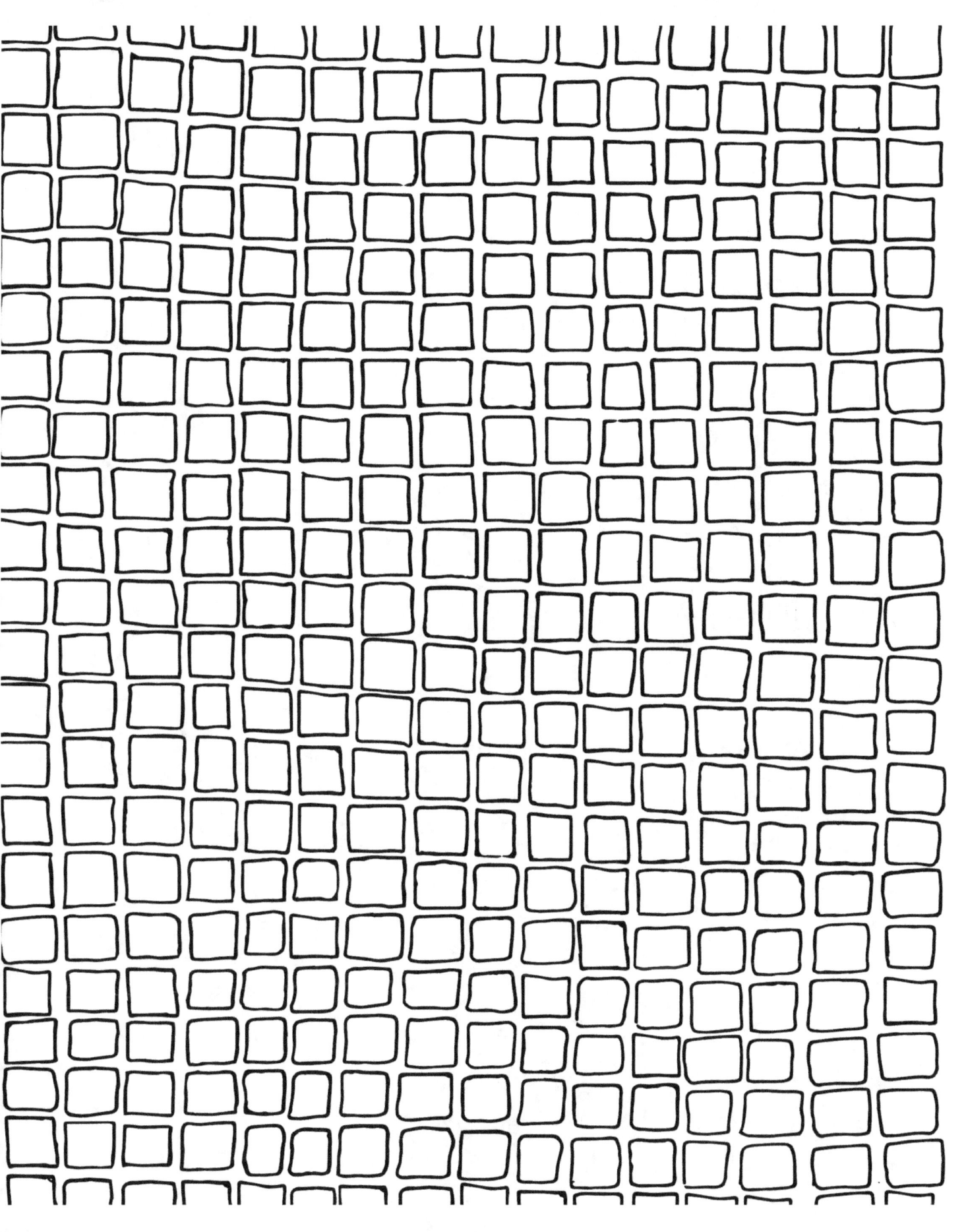

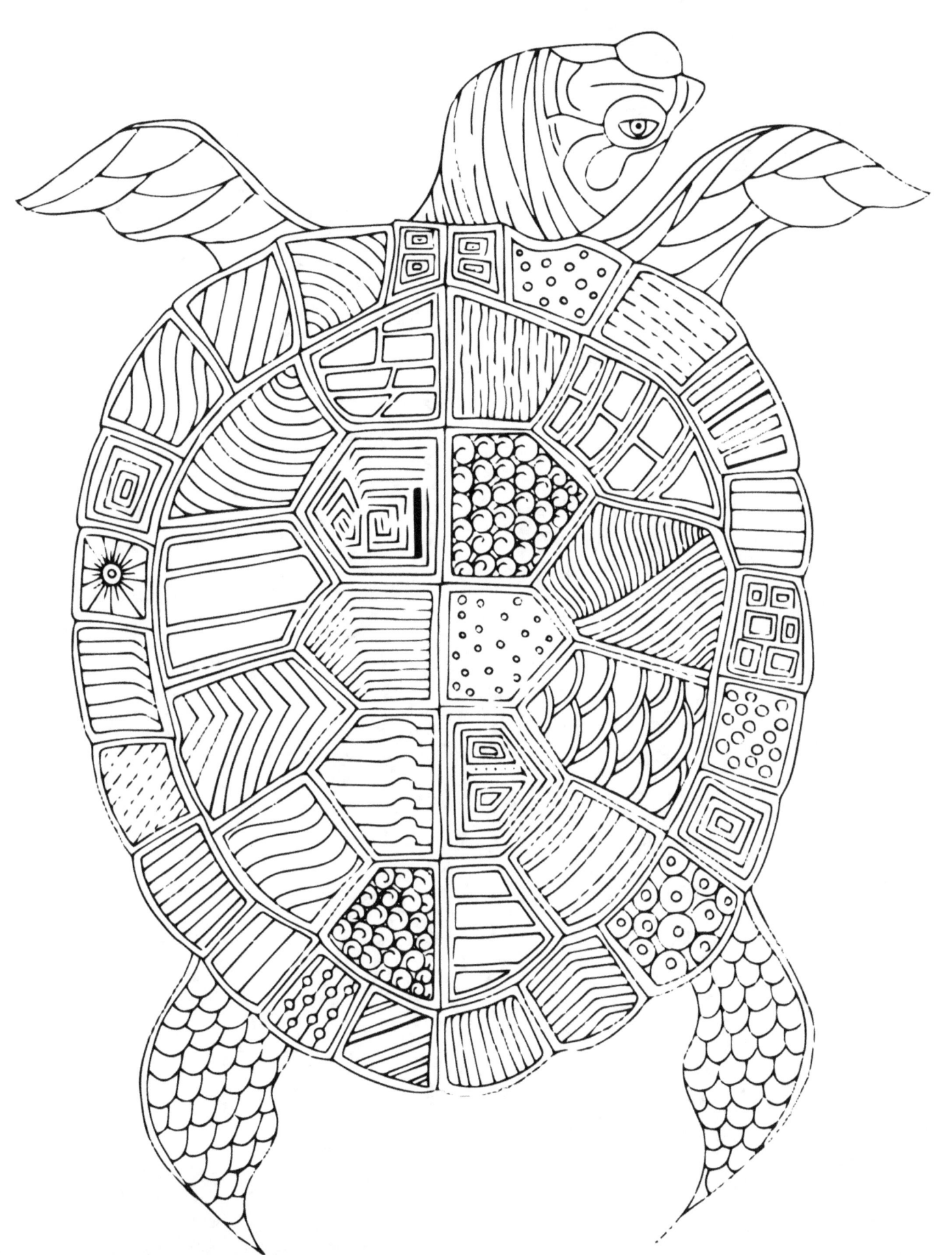

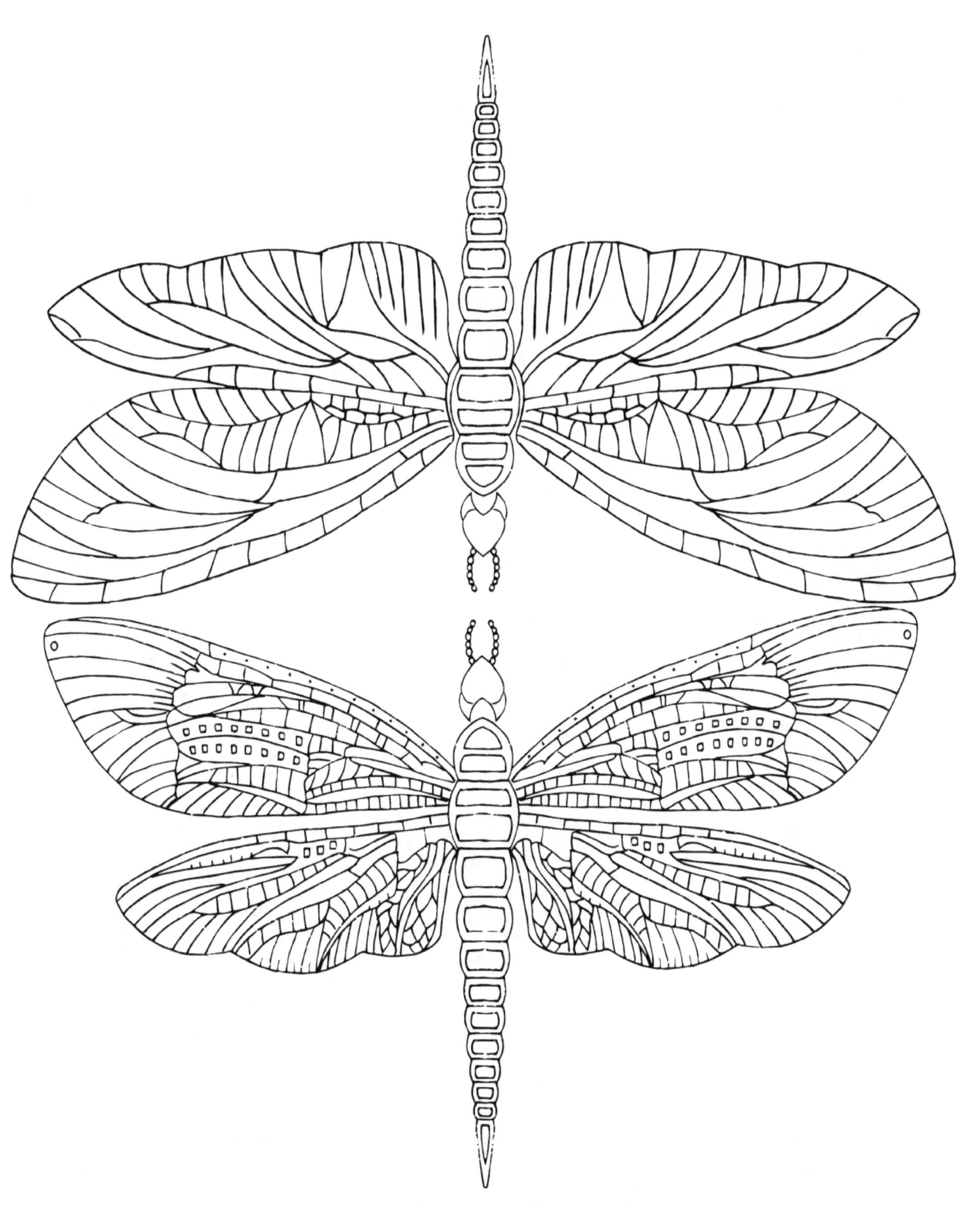

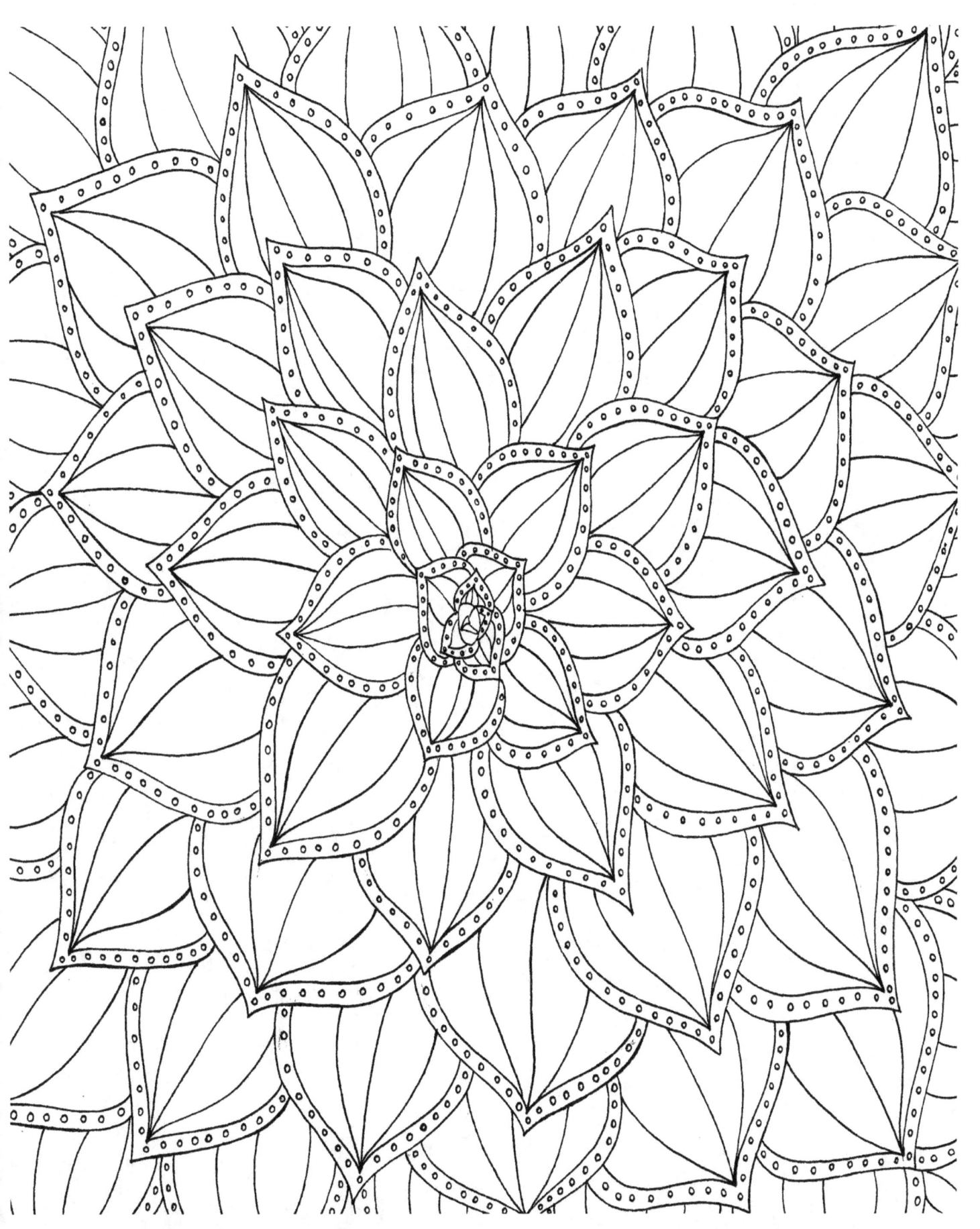

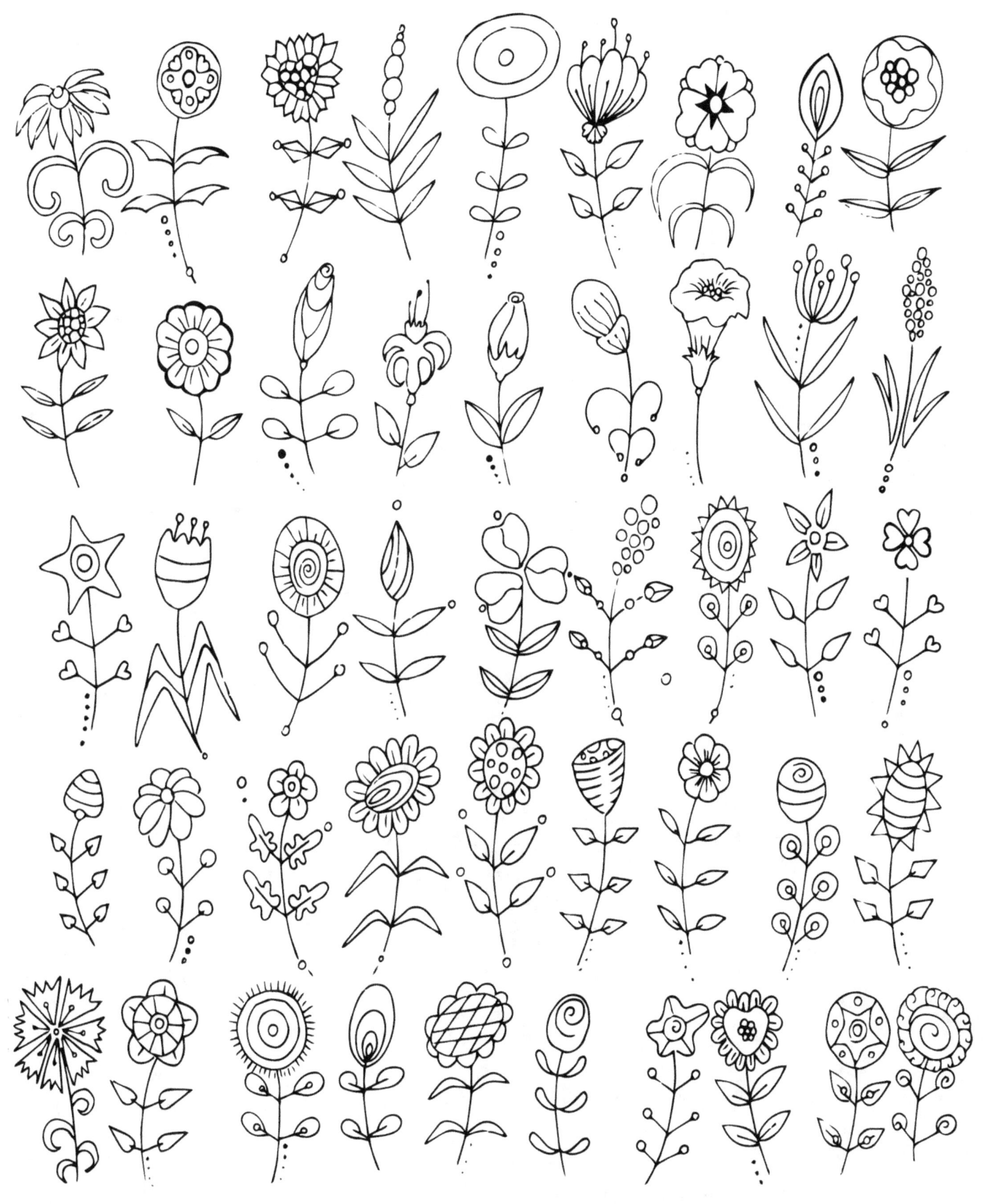

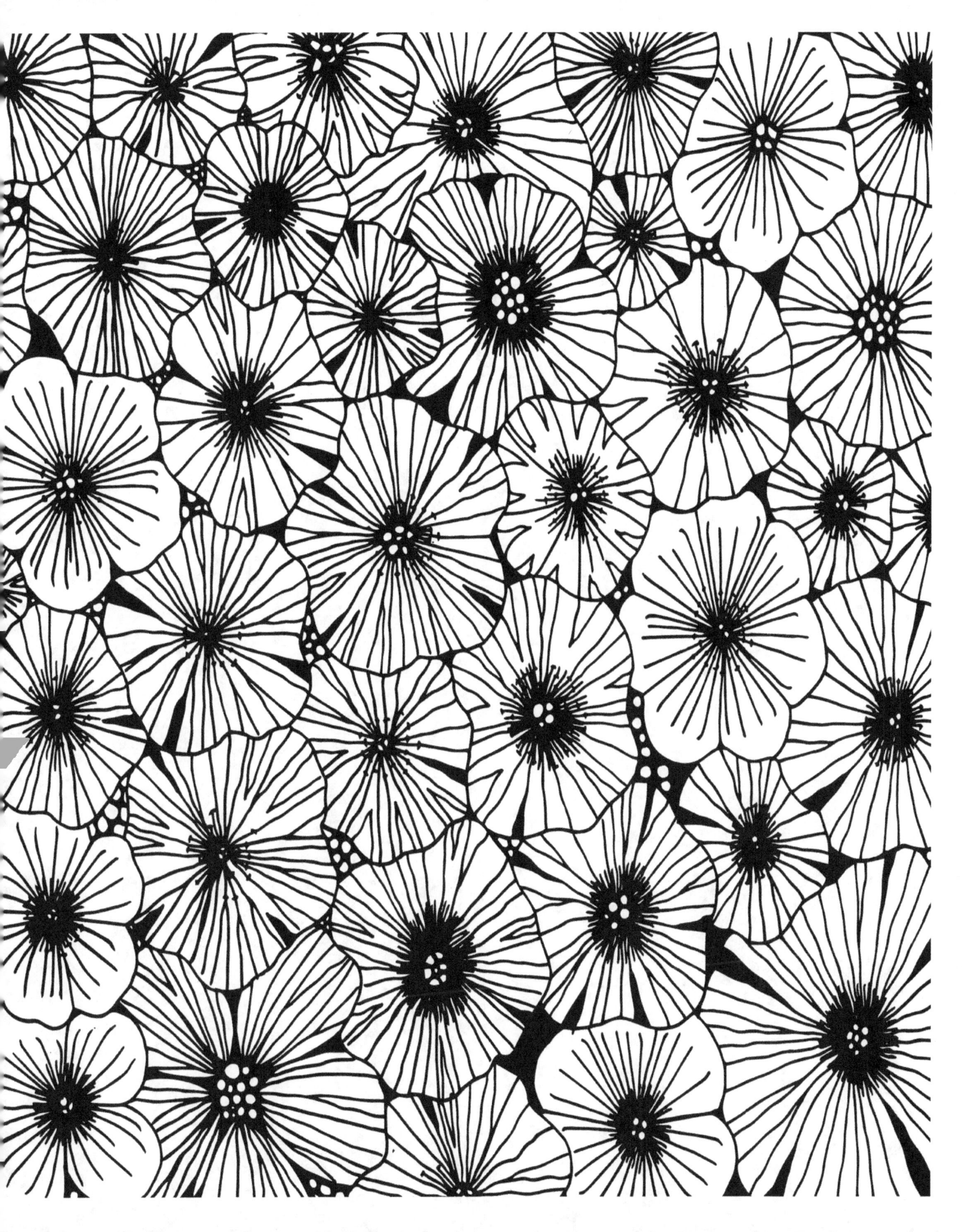

Color palette page

Color palette page

Color palette page

Color palette page

The end

www.ingramcontent.com/pod-product-compliance
Lightning Source LLC
Chambersburg PA
CBHW081012170526
45158CB00010B/3014